THE LEFTOVERS

The Leftovers

FIRST EDITION

Copyright © 2018 Shaelyn Smith
Printed in the United States of America

ISBN 978·0·914946·00·7

DESIGN ≈ SEVY PEREZ
Text in Klavika and Adobe Caslon Pro

COVER IMAGE
"The Leftovers" (2017)
Laura Peterson

This book is published by the

Cleveland State University Poetry Center
csupoetrycenter.com
2121 Euclid Avenue, Cleveland, Ohio 44115-2214

and is distributed by

SPD / Small Press Distribution, Inc.
spdbooks.org
1341 Seventh Street Berkeley, California 94710-1409

A CATALOG RECORD FOR THIS TITLE IS
AVAILABLE FROM THE LIBRARY OF CONGRESS

THE LEFTOVERS

SHAELYN SMITH

SMITH

"What is always needed in the appreciation of art, or life, is the larger perspective. Connections made, or at least attempted, where none existed before, the straining to encompass in one's glance at the varied world the common thread, the unifying theme through immense diversity, a fearlessness of growth, of search, of looking, that enlarges the private and the public world."

—Alice Walker, "Saving the Life That Is Your Own: The Importance of Models in the Artist's Life"

AND SHE GATHERED ALL BEFORE HER 13

TABLE OF GRIEF 19

ECONOMY OF THE HOPELESS 29

I SEE MYSELF IN YOU 55

ORIGINS 69

NONE OF THIS MAKES IT INTO THE STILL LIFE 93

ARCH OF NEMESIS 119

THE LAST SUPPER 137

SALT OF THE EARTH 173

JUST BEFORE THE BLACKOUT 193

WORKS REFERENCED & NOTES 207

ACKNOWLEDGMENTS 227

Judy Chicago was born Judy Cohen. At age 23, her husband of two years died in a car crash. He sped off a cliff. The friend who found his body told Judy he was covered in ants. And then she was alone. Every day she painted her sadnesses onto canvas. She began to use her late husband's surname, Gerowitz, though she hadn't taken it formally during marriage. Her professors criticized her paintings, the faculty made fun of her abundant use of breasts and wombs. She did not intend for these forms to take shape. But what of intentions. She took up spray painting. She attended auto body shop classes at night. Her professors told her she'd have to decide if she wanted to be a woman or an artist. A gallerist in Los Angeles took an interest in her work. He began calling her "Chicago" because of her thick accent and because the moniker—with its soft and hard C, the full glottal stop—made her seem tougher. She started smoking cigars. Behind the spirals of smoke, her eyes wandered with a nostalgia for home, the blue-collar city tugging at her trousers.

An early critic of Chicago's told her that she "couldn't be a woman and an artist too." She later said, "to put it bluntly, I became increasingly pissed off by the ongoing rejections, put-downs, and misperceptions." She legally changed her surname to Chicago, put on big boots, rented boxing gloves, and staged a photograph for *Artforum* declaring herself ready to fight. She took run of the ring. This was 1970 and Chicago intended to represent all the adjectives her new name signified: defiant, capable, resourceful, hardscrabble, determined, proud, guileless. In a series she made shortly thereafter, called *Rejection Quintet*, Chicago scripted those collective insults in

fine calligraphy across the bottom of detailed, violent drawings of cunts, all sharp edges and soft colors. Stories of being seen through the wrong eyes, of simultaneously being too visible and not visible enough, of having her metaphorical flower split open again and again and again, of courage to push through to the other side. She'd later write in her autobiography that female artists have three options: they can commit suicide, work in isolation, or resign themselves to lack of recognition.

*

In 1974, Judy Chicago said fuck all that, threw her gloves aside, and bare-knuckled a knockout. She got to work on *The Dinner Party*, which she hoped would end the occlusion of women's achievements from the historical record. *The Dinner Party* took five years to complete and looked then as it does now: a table constructed out of three wings, each 48 feet long with 13 place settings, arranged in a triangle that takes up almost 1,000 square feet, honoring 39 women who were written out of a millennium of history, complete with table runners tailored to each woman's life and accomplishments. Each place setting consists of an intricately embroidered runner, flatware, a goblet, and a yonic-inspired ceramic plate suggestive of the female form, some more explicit than others. Each plate is 14 inches in diameter. The floor beneath is cast of 2,000 hand-tooled pearly ceramic tiles, the names of another 999 women scripted in gold upon them.

The Dinner Party lives on the fourth floor of the Brooklyn Museum. For the last nine years, it's found a permanent home in the Elizabeth A. Sackler

Center for Feminist Art. In the small theater that connects the room housing *The Dinner Party* with the rest of museum hang plaques of triangular glass for women honored with a "Sackler Center First Award." This award, designed by Judy Chicago, and presented by Gloria Steinem and Elizabeth Sackler, pays respect to "extraordinary women who are first in their field"—a virtual fourth wing of the party, to keep Chicago's project current and expanding. Seven of these 18 awardees are women of color, diversifying a monochromatic presence at the table itself. The most recently inducted was Angela Davis in 2016, and Miss Piggy before her, welcomed to the wing by Sandra Day O'Connor, Connie Chung, Julie Taymor, and Toni Morrison.

*

The Dinner Party is held in a canted, black glass room in the middle of the gallery, a triangular room made specifically for the triangular table. The angled walls surrounding the installation are made of the same black clouded glass as the museum entrance, with a clear membrane running up each corner to allow anticipatory glances from the external gallery exhibits. Susan Rodriguez, the architect of the space, says "*The Dinner Party* gallery's design reinforces the artist's intention to 'elevate female achievement in Western history to a heroic scale traditionally reserved for men.'" The table is lit from above and below, tiny penlights in the floor and ceiling illuminating the work, casting vast and cavernous shadows.

Upon entering the exhibition, one walks beneath six banners, each five feet long, embroidered in black and white and red and yellow thread,

pronouncing: "And She Gathered All before Her"; "And She made for them A Sign to See"; "And lo They saw a Vision"; "From this day forth Like to like in All things"; "And then all that divided them merged"; "And then Everywhere was Eden Once again." One exits the exhibition through the room of Heritage Panels, which detail the biographies of these 1,038 women, accompanied by portraits and photographs of artifacts. Chicago's goal was the unilateral "goal of feminism—an equalized world." One might feel that this space is sacred.

*

The evening of the premiere of *The Dinner Party* at the San Francisco Museum of Modern Art, March 14, 1979, Chicago felt good. A friend had come over to do her make-up, another friend to lace flowers through her hair. She counted this among one of the best nights of her life—all this work. But the subsequent museum tour for the exhibition collapsed, and in the months following, a postpartum depression set in—all that work. Chicago went for long runs around a park in her Benicia, California, neighborhood. Annie Leibovitz came to her apartment to take a photograph: Chicago stands in the hallway that leads to the exit of her walk-up; the frame can't contain her. Her long legs cast shadows on the wall, one hand at her mouth and the other in the pocket of her high-waisted jeans. She smirks like she knows what's beyond the next horizon.

*

In 2017, at age 78, a week after her birthday, Judy Chicago posted a picture of herself on Instagram with the hashtag #clubclitoris, referring to a collaborative effort with the Jessica Silverman Gallery, where her solo show "Judy Chicago's Pussies" was about to open, with a celebration of *The Dinner Party* coming quick on its heels. 2017 marked the tenth anniversary of the exhibition finding its home at the Brooklyn Museum: a gallery takeover that displayed never-before-seen plate prints and other ephemera from the hours spent creating the piece—all that work.

In the photo, "Aging Artist with Vulva Chocolates," Chicago is supine and topless on a Persian rug patterned in deep maroon and khaki florals. Her jeans are unbuttoned and unzipped, revealing black panties, the denim worn and faded at the waist. She's got gold foil hearts perched pastie-like atop her nipples, her breasts tan and supple. Her left hand is behind the small of her back; her right hand points a gold-plated antique revolver at the photographer. Her eyes are hidden behind pink zebra print plastic sunglasses that reflect the ceiling, teeth bared behind a dark maroon lipstick. Her eyebrows thin and as red as her hair. She looks satisfied, happy, defiant. Eighteen vulva-shaped chocolates rest like scarab beetles along her torso, arms, on her cheek and forehead. In 1973, right before beginning *The Dinner Party*, Chicago made a painting titled *Heaven Is for White Men Only*—its geometrics still echoing around us all these decades later. Her challenge to the future, laid bare before her.

TABLE OF GRIEF

Judy Chicago's curriculum for *The Dinner Party* suggests that teachers use the installation to introduce elementary-aged students to the concept of metaphor. "What else can the table stand for?" reads one exercise suggestion. Table as refuge, table as offering, table as community, table as provision, table as love.

In dreams, tables represent judgment or legislation, livelihood or sustenance. Clearing the table indicates a cessation of blessings. Table as tradition, hobby, nature, memory. Table to which we come. Table from which we leave.

*

While Ana Mendieta was studying art at the University of Iowa in the early 1970s (having left Castro's Cuba as a child in 1961), a fellow student was raped and murdered. For Mendieta, the campus reaction was not enough. In April 1973, she invited faculty and students to stop by her apartment. She had left the door ajar. When they entered, they found Mendieta bent over and bound to the kitchen table, pants and underwear around her ankles. Her ass, thighs, calves bloody with handprints, scratched and bruised. Shards of plates and unopened mail on the floor. A lamp illuminated her backside, casting a brutal shadow on the wall. A crime scene recreated: a pool of vomit, her flannel shirt shoved up her midsection. The attendees stood silently, then discussed her performance piece, "Untitled (Rape

Scene)," amongst themselves. Mendieta didn't move from her position for over an hour. She said after, "It really jolted them."

*

Carrie Mae Weems's *Kitchen Table Series* documents a woman sitting at her kitchen table with her lover, her daughter, her friends, alone. The photographs in the series are untitled. In "Untitled (Man and Mirror)," Weems sits at the head of the table—a cosmetics mirror in front of her; a pack of Camel cigarettes, a fifth of scotch, and a highball glass to her right; to her left, a comb and a brush—while over her left shoulder a man in a hat leans toward her neck for an embrace. She stares defiantly into the camera.

In "Untitled (Woman with Friends)," Weems sits at the table with two other women. Behind them is a large abstract tapestry. The room is warm. The women are vibrant, dynamic, laughing. The camera has captured streaks of motion as though a tense conversation was interrupted with an unexpected joke. They each have a half-full glass, whiskey or water or wine, hands slapping the table. Weems taps a cigarette, a knife in the center of the table next to the ashtray.

In "Untitled (Eating Lobster)," Weems sits in a chair beside a man at the head of the table, her hand cupping his cheek as he uses both hands to suck out the meat of a lobster. His wine glass is nearly empty and three Budweiser tallboys threaten his elbow room. Her glass of wine is full, a cigarette balanced between the fingers of her resting hand. Her eyes are

closed and her mouth is pursed for a hush or a kiss. She wears a neat satin silver dress, small hoop earrings. There's a parakeet perched in a standing birdcage in the corner, a stack of playing cards at the forefront of the table. Her lobster is untouched, rubber bands still holding shut its claws.

In "Untitled (Woman and Phone)," the phone sits shadowed in the foreground. At the other end of the table: a bottle of wine, a glass half empty, an ashtray full. Weems, shrouded in sheer black fabric, sits at the head of the table, knees up to forehead, arms wrapped around her legs, face obscured.

<p style="text-align:center">*</p>

Elizabeth Sackler, founder and benefactor of the Sackler Center for Feminist Art, is a prominent philanthropist of the arts, and in 2014 became the first female chairperson of the Brooklyn Museum. The Sackler family wealth is from pharmaceuticals and advertising. In her autobiographical statement on the Brooklyn Museum's website Sackler writes that she "does not think of [her]self as a benefactor" but instead a "social and arts activist" who is thankful that "financial resources have enabled me to create an enduring activist declaration." In 2013, Sackler gave a small series of lectures about *The Dinner Party* at the York County Correctional Institute, a few hours northeast of the city. Some of the women expressed interest in learning more, so Sackler continued to visit. She helped a group of these women make their own plates using what few resources they had access to: paper plates, plastic cutlery, bible pages, yarn, Styrofoam cups, bars of soap, cardboard. The process took about six months to complete. The group called

themselves "The Women of York." One woman, Lisette Oblitas-Cruz, who has since been paroled, said the process was more difficult, but also more productive, than she expected.

<center>*</center>

Working on plates of their own helped the ten women who participated in the *Dinner Party* project reclaim the space of the table and honor a woman of significance in their lives. These honored women ranged from mothers and grandmothers to Eve and the Virgin Mary, Juliet Capulet, Danica Patrick, Princess Diana, and Malala Yousafzai, for her understanding that creativity and education are basic human rights everyone deserves regardless of their situation. In the center of the triangular table are the names of many other women the artists wanted to honor, just as in Chicago's piece. One woman made a plate for feminine energy, all green and purple and red-orange. Oblitas-Cruz commented on how the project made her feel whole again.

The final installation, *Shared Dining*, was displayed at York Penitentiary, where the creators served as docents, elucidating the artwork and giving tours to correctional officers and fellow women incarcerated at the facility. *Shared Dining* appeared next at the Brooklyn Museum in the late summer and early fall of 2015 in the gallery where Chicago's *Dinner Party* also lives. These plates don't take on the vulvar imagery of Chicago's but instead are representative of spiritual guidance, a holistic narrative: Danica's place setting is the black and white checker of the NASCAR flag, Juliet's plate

a knife carved out of soap, Eve's an apple crocheted with yarn and staples, Princess Diana's a likeness of her face, and Malala's a gold-painted plate, decoupaged with her picture and a quote from the newspaper: "Malala is a symbol of hope, what is possible, the triumph of good over evil." There's a pencil, a big splotch of pink at the middle of the plate, a tiny book opened to a page that reads: "Malala triumphed against all odds." Inherent in this quote is a question: what odds are we all up against? We, women. We, the incarcerated. We, artists.

On a panel the night of the exhibition's opening, Oblitas-Cruz said, "We were our own worst judges. We'd look at our placemats and say, 'How do I make this art piece happen? Does this look good?' But we empowered each other, and there was a sense of sisterhood, which was so unlikely in prison. You usually have to wear a mask, otherwise people walk all over you." Oblitas-Cruz made a plate for Phyllis Porter, the woman who died in the accident for which she was serving time.

*

According to a 2013 article in the *Norwich Bulletin*, at the trial, Oblitas-Cruz said that "a part of me died with her." With the judge's permission, all of Porter's children filed out to hug her after the indictment. They offered these words: "We forgive you. We all make mistakes." Oblitas-Cruz has said that the only times she felt "free of pain and guilt" in prison was while she was working on the plate. She said that the process was never easy, but it was healing. Now that Oblitas-Cruz has been paroled, she says

she would like to return to the facility to teach art classes and help others have the experience she had. Stephanie Weissberg, the curatorial assistant of *Shared Dining*, says the piece "speaks to the multiplicity of stories that can continue to be told, not just of women who were historically and canonically famous enough to be researched by Judy Chicago, but also women who maybe are lesser known, but significant to individual people."

*

In a dark corner of the Brooklyn Museum's fourth floor sits a bust of a woman who wears a light pink cloak over her head. It flows down her shoulders, ending at her upper arms, her breasts giving way to the rectangular marble pedestal that supports her. Her breasts are slight; her blouse tiny buds interspersed with polka dots. She looks downward, delicately featured and rosy-cheeked. She is made of white earthenware, part of the Wedgwood collection. Her lips purse slightly, as though she wants to say something, but she doesn't; a long time ago she decided she wouldn't. Her name is Sadness.

*

In 2005, an exhibition at the Thomas T. Taber Museum in Williamsport, Pennsylvania, opened to the public. *An Empty Place at the Table* is a candlelight vigil in remembrance of victims of domestic violence. The year

before, in the small communities of the surrounding county, 110 people were murdered in cases of domestic abuse. A long table sits in the middle of the dark gallery, lit from the center with white tapered candles in star-shaped crystal chambersticks. Each place is set with a rolled napkin, silver flatware, a drinking glass with nothing in it, a cupped plate. In black marker on the rims of each plate is a date of birth and a date of death. In the center of the plate, a name scripted in gold. There are no chairs.

The tablecloth looks patterned from a distance, some fancy fabric, but when approached tiny silver script reveals itself: the words of these women, their stories of the violence enacted upon their bodies by those they trusted, loved, could not hide from, could not escape. At the opening, the Ebenezer Women's Choir performed. Another woman, Rebecca Kinzie-Bastian, stood to read a ekphrastic poem after Frida Kahlo's 1946 self-portrait *The Wounded Deer*. The poem, titled "The Little Deer," ends: "crimson, killer, look me in the eyes / and know I see you. / I am pain pulled / tight against you. I am your mirror."

*

In one of Anne Carson's *short talks*, "On the Mona Lisa," she writes: "Every day he poured his question into her, as you pour water from one vessel into another, and it poured back." The entire canvas of Gerhard Richter's 1968 painting, *Zwei Frauen am Tisch (Two Women at Table)* is a smeary slate-blue. In the middle are circular marks smudged by a finger in white paint. In the upper right quadrant of the painting is another white figure, a more discernible face, eye holes gaping to reveal the gray of the background.

Carrie Mae Weems says of her *Kitchen Table Series* that she used her body "as a landscape to explore the complex realities of the lives of women."

*

When Judy Chicago's first husband died, she started a land art project. She'd venture out into the desert and to the ocean shores and set off bombs that detonated into explosions of color carried off by the wind. This is how her grief dissipated: by smoke and fireworks, into the air we breathe.

Chicago says she intended this series, *Atmospheres*, to liberate her work from a specific structure and to soften and feminize a harsh landscape. She meant to convey emotion in the form of color: the parks of Pasadena and shores of Santa Barbara temporarily flushed lavender, mustard, salmon. These were temporal pieces, dependent upon wind, weather, and time.

One performance in particular, entitled "Smoke Bodies," took place deep in the California desert. A photograph shows three women in various positions—one's body painted purple, another's green, another red-orange. They are setting off multiple smoke bombs, each color correlating with their body paint. Plumes of smoke drift up and thin out across the open sky. Grief becomes a part of us as it disappears, filling whatever gaps it can.

What the images don't show is that when Chicago was learning the pyrotechnics necessary to purchase the equipment for *Atmospheres*, the fireworks company required her to do three formal practice shoots with an employee. During the final shoot, the representative who accompanied her got down on the grass and "began humping the ground, saying, 'I could do it to you right here.'" She didn't work on the project again for several years.

ECONOMY OF THE HOPELESS

The Ford Bronco David Tyll and Brian Ognjan drive up north on their hunting trip in the fall of 1985 is never found. Neither are their bodies.

*

If you were driving north on Mapes Road just past the village of Luzerne, you probably wouldn't notice a dirt turnoff to your right, flanked by red cedars and eastern hemlocks, if you were going the 55 MPH speed limit allotted by law, but especially if you were driving the 70 MPH speed limit set by locals. You might slow down just past it to cross a small bridge that runs over Lost Creek, a tributary of the Au Sable River, especially if it were winter when northern Michigan backroads get slick with invisible ice. You might slow down just past this bridge if you were headed to Lost Creek Sky Ranch. The Ranch changed ownership in the late 1990s but everyone still calls it Linker's.

*

You might be headed to Linker's for a few beers, some big sky nachos, or to tumble down the grassy ridge behind the building to the baseball diamonds below. You might be headed to watch a game. You might be headed

to play one. If you were playing said game in the early 1980s, you might be playing against Coco Duvall, who would have changed out of his characteristic wing collar, paisley-pattern silk shirt, unbuttoned halfway down, chest hair billowing out. Coco would still be wearing his characteristic gold chain, flashing now as he pitches you a curveball you never saw coming.

*

I'm in the front seat of a dull gold Chevy Trailblazer, all strapped in with the windows down. My father says, *I know where that Ford Bronco is*, and I hang my head out the window, wagging my tongue like a dog. I retreat, ask, *where*. He says, *You know that used car lot on M-33 and Ogemaw Center Road?* I think: you mean next to the cornfield I sprint to when cops show up at a Morrison Shack party? I say: *You mean the junkyard you promised you'd buy me if I win the state cross-country meet?* He says *Yes, that's the one, that's where that Bronco is.* He says, *No one pours a parking lot past midnight unless they're hiding something. They laid that concrete at 3 a.m.* I don't ask him how he knows this.

*

If you hadn't seen the turnoff you definitely wouldn't have noticed the house tucked behind a row of undergrowth and aspen trees directly opposite the clearing—a generic light blue, two-story number that slumps

with its own weight, tired and worn with years of hard seasons. The kind of house that wears its age like a face, surrounded by evidence of its inhabitance: a rusty wheelbarrow, a Little Tikes kitchen set covered in a film of grime, worn wood rakes and feral geraniums, a 1970s Pontiac up on blocks, palettes, Budweiser cans, cigarette butts, ceramic pots, half-bags of cat litter, a burn barrel, deflated beach balls, a trampoline serving as a chopping block for badminton rackets, crochet needles, hula hoops, other abandoned hobbies.

If, in fact, you did see the turnoff, and happened to pull into it, you'd find yourself in a crop circle of wildflowers and tall grass. You might turn around or instead take pause; note two small white crosses and a pail of fabric flowers wholly faded with sun. Hand-painted on the larger cross are the names "David" and "Brian" in pink; on the smaller cross: "Brian" and "David." Some plastic ferns wing out from behind.

*

A hunter passes out in a tree shanty while waiting out the deer. It's out of season, but he's stealthy at traversing the law. When he comes to, it's nearing sunrise—the forest around him that searing twinge of light that comes when the birds start singing and the world wakes up. The hunter burps, sits up, tries to get his bearings. He thinks he's somewhere on state land. He'd been dreaming of a long, lean doe; he'd been dreaming of the divorce papers and how he has yet to sign them. He feels the dank, sharp tang of a beer and whiskey cocktail in his mouth, the beginnings of a

head-pounding hangover. He starts to gather what he's got: his hunting pack, an overturned cooler; realizes he still has a few full beers, a quarter pint of whiskey. He slugs it. The sun sends out orange feelers that finger their way into the trees, turning the leaves above him translucent. As the birds reach a crescendo, a group of white-tailed deer wanders into his range. He takes up his rifle, hastily points. He fires. The deer scatter and the birds are silent. He heads home.

*

The bullet embeds itself elsewhere.

*

Randi is fast asleep in her older half-sister's bed. She's eight years old and her half-sister is gone for the night, at a friend's or something. Her half-sister has been experimenting with bulimia and tucks away each night's dinner in plastic grocery sacks of vomit lining the top shelf of the closet in their shared room. No one ever says anything about the smell. The girl is entering a REM stage, tangled up in Mickey Mouse cartoon sheets, sleeping with her head at the foot of the bed. Randi's real father is Native American; Randi is just figuring out what this heritage means. She's dreaming she's a wolf; she's dreaming she's a wolf being hunted. Her legs are twitching with the chase, like a dog's, and then she wakes up. She's not sure why she's

awake—an abrupt end to the narrative. She feels something warm and sticky on her thighs, a thick viscousness that can't be urine. She puts a hand down, swipes, looks at it in the orange light filtering through the curtains from the porch. It's definitely blood, and she's convinced she just got her period. She knew it would hurt, but she didn't know it would hurt this much.

*

My dad's standing at a urinal. Roger, a work buddy, has asked him to be the best man at his wedding. J.R. Duvall walks up to the urinal next door, not to pee, but to lean his elbow atop it. He sizes my father up and says, *We know how to take care of people like you.* He spits, turns, walks out.

*

Pigs, they say, will eat anything. It's said that a herd of 16 pigs can devour the body of a 200-pound man in eight minutes; that they will cut through bones like butter.

*

Randi sits up. Vigorously ripped out of dreamspace this time by the

blood on her hands and the twang in her thigh. There's a hole where there shouldn't be a hole, in her thigh. There's a hole where there shouldn't be a hole, in the wall, just left of the window. There's blood where there shouldn't be blood; this isn't what she learned about becoming a woman. She can't move. She screams and screams, as if she's still being chased.

*

I find the Duvalls on the Michigan Department of Corrections website, where they are identified by offender number, physical description, conviction. J.R. looks like a man I'd meet at church. Coco stands about my height.

*

When Barbara finally concedes to witness, eighteen years after the fact, she warns the sheriff that he's gonna get her killed. She swears their heads smashed under the bat like watermelons, a swift crack, and a spray of hot pink, seed-studded flesh across the snow.

*

My dad's over at Roger's to check out some problem with his car, it's after

work and he needs a second opinion. They're in the garage all lubed up when Roger's sister, Connie, shows up—two black eyes and oozing a thick, crackling blood from her left temple. Roger hasn't seen much of Connie since she moved into Coco Duvall's place. She's shaken and shaking, her skin ashen, lips dry and split. She deadpans that there's been an accident, maybe she says there's been a wreck. Roger tells my dad to leave, he's got it from here. My father doesn't say anything to Connie, grabs his jacket, nods his way out.

*

Barbara doesn't even want to go out that night, but Ronnie convinces her: a few beers at Linker's, just down the road, he's itching for some company, come meet me, *Scarface* is playing for the eighth time that month at midnight, they can be home before that. Ronnie is her best friend, she loves him and he never expects anything in return. All the men in town snigger at him and call him "funny" but Barbara doesn't care, he's the only person she can really talk to. He keeps insisting and she finally relents, *Sure, one or two, it's already snowing, whatever*, and straps on her boots.

*

My father has convinced my mother to come celebrate a softball championship win at the bar. In this story, she's pregnant with me but hasn't

told him yet; maybe she's not convinced it'll stick. Coco, or J.R., she can't remember, corners her under the dartboard and swears to god they'll get my dad back for that game. First, he tells her she looks real pretty. He tells her she's practically glowing under the neon lights.

*

Later, the drunk hunter will finally sign the divorce papers and spend some time drying out in the county jail, picking up trash along M-33, the highway that runs past manure-laden fields and the local high school. The insurance payout will buy Randi her dream bedroom set for the attic build-out her family put on hold when they ran out of construction money. She'll choose a brushed metal canopy with a butterfly headboard, light blue paint for the walls, spongey clouds spattered across the alcove ceiling. In seventh grade, we'll gather around this bed to play the pass-out game. It's late, we've already had a séance, in the teenage-girl style of such: light as a feather and stiff as a board, scented candles, useless incantation, Ouija board shuffles, a desperate attempt to hold hands, a tender touch that now, nearing high school, is only acceptable with those of the opposite sex.

*

My father finishes his stream of Busch Light piss, shakes off, retucks his tie, washes his hands, and smooths out his beard. He leaves the bathroom

and beelines for my mom, sitting by herself looking all homespun teen dream prom queen in the lace and tulle dress she sewed weeks before in preparation; blue eyeshadow caked to the brow line, a shade of pink lipstick that doesn't quite fit her olive tone. My father wants to leave, they are overdressed, it's embarrassing, but they can't, he's the best man and they still have yet to toast. It's their first wedding in northern Michigan, my mom's working part-time at a bank and my dad is mucking horse stalls and driving around the backcountry checking levels on the county pump jacks, which is exactly how he met Roger. My folks don't know any better, the ceremony's all mixed up with the reception at the county fairgrounds, all the other weddings they had been to, including their own, were in churches.

*

It's my eleventh birthday party and Randi comes over. Mary does too. We eat too much pizza and dance to the *Harriet the Spy* soundtrack on repeat until the tape rips. We sneak over to the neighbor's house. We peek in the windows and steal a beer from the fridge. It's nearing midnight and Randi, in a lull after the one-beer-split-three-ways, convinces me and Mary that she can hypnotize herself; she learned it from her therapist. We squeal and shout, swaddled in our oversized sweatshirts, but she starts to anyway. And she does it. I'll talk with Mary a decade after the fact and she remembers what I do: we sweat like pigs and cuddle together in a beanbag corner while Randi enters an uncontrollable state of possession. She doesn't use her real voice, she levitates, she makes predictions that will later come true. Eventually she passes out. We shake her, trying not to wake my parents, until she

finally comes to. She'll swear she remembers none of it. She won't believe us.

*

Driving north on Mapes Road, you might turn left off Old 72 and curve east on Ryno Road, before the clearing, before Barbara's house, before the bridge, before Linker's. You would be headed out toward Amish Country. First, you'd pass the house of the man who built the house I grew up in, and next door lives the guy who put in the plumbing. You'd drive through a few burned-out jack pine fields, then you'd pass the turnoff for Lake Mio, which is really just a dammed-up, jammed-up part of the Au Sable River. People fish there, but mostly sit on the banks to get fucked up. You'd also be out close to The Machine, one of the designated party spots on state land for high school kids to meet up and drink and touch each other in the dangerous topographies of the dark. Lake Mio is close enough to get to if you just need a few minutes to collect yourself closer to the water. There's also a nice outhouse if you're too chicken to pee in the woods.

*

The thing is, Randi's parents never fix the hole in the wall. Sometimes when I'm over there I sneak into the room, slip my index finger in the hole, move it in and out, trying to imagine what a bullet even feels like, in and out, the crumbling drywall dusting my hands in a fine, druggy film.

*

I'm in the backseat of the dull gold Chevy Trailblazer with my little brother. We're going to Amish Country to get some rabbits for dinner. My father makes a stop, pulls into a driveway. There's been a freak hailstorm and the well's damaged. He rolls down the window and shouts, *Hey Jim! Got the day off?* He shouts, *Working on your own house when you could be making money!* Jim emerges from his basement hatch scowling, smiles when he sees my dad. They're old softball buddies, this is how errands are run here. This is how things get taken care of.

*

When Brian Ognjan goes missing his fiancée sleeps alone in their new house for the first time. She told him: *Come back soon, we have a wedding to plan.* Brian isn't back in time for the appointment they've set up for early the next week, so Jan goes to the cake tasting alone, walks out afterward, buzzing a chocolate-, cherry-, coconut-induced stomachache, this frosting headache, nausea rising up inside her. As she unlocks her car, she remembers Brian doesn't even like cake.

*

When David Tyll goes missing, his wife Denise assumes he's having a mid-life crisis. She's watched it coming: flirting with younger women, staying

later and later at work, not looking at her like he used to. She figures this hunting trip is par for the course, so she tucks in, not thinking twice, she can't bear to. Then two cops come knocking at her door; she realizes her mother-in-law has called the police, that this might be something serious. She answers their questions, shows them the inside of her deep freeze, lets them search whatever they want. She doesn't say another word. After they leave, she empties the laundry hamper onto the bed and sleeps in his scent—the piss and sweat and cum—like she knows David's never coming back.

<p style="text-align:center">*</p>

Genetically, pigs are very close to humans. A pig's heart will beat in the chest of a man; a pig's skin grafted upon your own will continue to grow, as if it had always been yours.

<p style="text-align:center">*</p>

We're in eighth grade when Buddy shoots himself in the head in his parents' backyard. He's in tenth grade, leaves school early that day. I don't really hang out with high schoolers too often, but Katie knew him. I think they made out at a few parties, the ones with raging campfires in fields out on state land, spots called things like 69, 420, The Pit, The Machine—places you'd never be able to find unless you already knew they were there. Katie

goes to the funeral and brings back the memorial card: name and dates embossed in gold. We run our fingers along the raised script as if we can intuit something dangerous and divine, something we feel deep within ourselves, for which we have no name. Standing along the lockers before pre-algebra, we are trying to cross a threshold that will lead us somewhere we can't quite comprehend. We are unstoppable in our witnessing of the dark. We are ravenous in our attempts.

*

I'm in the backseat with my little brother again. My father pulls off by a small branch of the Au Sable River brimming with sweet peas. They're in full bloom, snug around some charred, abandoned equipment most likely used to cook meth. He says, *This is the most beautiful place in the county. The water runs so clean under the road there*, my father tells us, but it's insidious in its daring.

*

In the fall of 1985, Brian Ognjan and David Tyll are supposed to visit friends just north of Detroit for their annual hunting trip. After they get in David's Bronco, though, they change their minds. Instead, they decide to visit an old high school buddy they haven't seen in years, who has a hunting cabin up north, in Oscoda County.

Now my father's an environmental analyst. He left the horse stalls for the pump jacks and the pump jacks for a cubicle and the cubicle for an office. Now he laments the traces of meth found in the ground water, and how much government money he's allotted to clean it the fuck out. Soon he'll retire, and the job will go to someone else.

*

After Randi screams, she passes out, she's so tired of screaming. She dreams of her step-grandmother's house, where everything is all doilies and tchotchkes, like my step-grandmother's is, too. She dreams of the mantle, angel figurines adorning it. She picks one up, she drops it; it shatters on the hearth, a tiny ceramic foot stuck between the bricks. She wakes up again in agony, remembering that it was me who broke it, and I never told anyone.

*

A few weeks later our respective parents drop us off to see *Anastasia*. We buy sour gummy candy and popcorn. Some high schoolers in the front row blow up condoms and float them in front of the projector where they seem like strange shadow appendages to the animated characters. Randi and I don't tell our mothers what time to pick us up. Once the movie's

over, we banter a bit in the direction of the older kids, purses seesawing at our shoulders. Then we walk through the alley between the hardware store and the local newspaper office. In the dark of the alley, Randi pulls down her pants and shows me her bullet wound. I've seen her thigh before, but never like this: shiny, pink and raw, the old skin tugging at its new scar, clamoring, pulling it away from the center—an almost-maroon, blinking toward black like the iris of an eye. I don't know what to say. I'm nervous my mom is waiting out front.

*

Barbara leaves Linker's with Ronnie after a few hours. Many more than two beers, and it's still snowing. *Scarface* probably hasn't even started yet, but they have yet to trudge home and reset the TV antennae, it doesn't really matter anymore. Also, they have real things to deal with. Some downstate hunter was being shitty to Barbara, grabbing her ass and buying her shots and challenging their pool game. Ronnie hadn't done much about it, but Barbara didn't really expect him to, she knew what they'd say to him. The Duvall brothers had shown up, though, as she knew they would. They always do. She said, *J.R., this guy's an asshole*, and J.R. confronted him with some ulterior motive Barbara was too drunk to figure out. Coco asks her if she wants to come smoke some pot with them, but she really just wants to go home, drink some vodka with Ronnie, fall asleep watching Al Pacino go all crazy on some motherfuckers.

*

I'm in the front seat of a white Chevy Malibu; I just got my learner's permit, bumping along a two-track on state land near Mio. I'm going to meet Randi and her boyfriend at an abandoned cemetery. It's supposed to be haunted. We're perched in the hatchback of his Jeep, taking hits off a bottle of Jäger-meister. We're just two miles from Linker's. Legend has it that at midnight we'll see train lights barrel down the overgrown tracks. We'll hear the blaring whistle, a little girl scream. The town witch is buried deep in the woods. Pour one out on her grave and she comes in the form of an unnamable bird. Randi wants us all to get naked. The fog descends: some flimsy slip of black tulle.

*

In 2012, a local farmer never comes back from the early feeding of his pigs. His family goes out to look for him and they find first his dentures and his hat, a soft pack of Marlboro Reds, his pocket knife. Then they start seeing pieces of his body. They assume he lost his balance, fell into the pen. The pigs, ravenous, mistook him for the slop.

*

When Barbara gets home, she realizes she didn't lock the back door.

Ronnie goes to tune the TV to *Scarface*, laughs out loud at some commercial. Barbara pours herself a vodka, drinks it, rearranges the photos and magnets on the fridge. She hears Ronnie mumble something, *What-the-hell?* confused. She shrug-stumbles in response, knocks a magnet off and curses, stoops to pick it up. Ronnie yells BARB! as she puts the magnet back on the fridge. BARBIE! She grabs two beers as Ronnie rushes into the kitchen, knocking one from her hand. He whispers viciously, *You gotta come see this.* She doesn't have time to reply, he has her by the elbow, dragging her to the front room. The TV is muted; he's turned off the lights. Across the street, there's a truck—Coco's—she knows it by heft, color, rush, and carry. Its spotlights are on four men: Coco and J.R. easily distinguishable in profile. Each recognizable in contrast to the other. The other two she can't make out, can't identify at this distance. She grabs Ronnie's wrist, digs her nails in.

*

I'm in the front seat of Randi's 2001 black F-150. This our girldom, our heavy-handed insurgence. Our inoculation into an unknown pitch. We weave the backroads splitting cigarettes, our fingers lacing the smoke. We skip school, music on the radio. We come together. We drift apart.

*

On the stand, the Duvall brothers maintain their innocence. Coco responds

to Connie's testimony by insisting that he was only joking that time he threatened to feed her to pigs if she didn't shut up.

*

Ronnie yanks on Barbara's arm, says, *Let's go outside*. She shakes him off. *This is silly*, she says, *Let's watch* Scarface *and pass out, I've got so much vodka*. He pulls her down, eyes peeled to the window, says, *No, this is for real, get your boots*.

*

Eight days later a farmer finds Ronnie's body flapjacked across Mapes Road a few miles north of Linker's. I'm talking flattened like you-just-saw-it-in-your-headlights-but-there's-another-car-coming-straight-on-you-can't-see-because-blare-of-headlights-big-ditches-either-side-no-swerve-it'd-do-more-harm-than-good-so-you-hold-your-breath-and-hit kind of roadkill, just past the clearing, just past the bridge, just past Linker's. But, in fact, there was no other car coming. The autopsy will determine Ronnie's body was put dead in the road before the tire tracks ran up over it.

*

Four days before Ronnie's body is found, Barbara gets a knock at her door, real early. She answers in her slippers, in her nightrobe, nothing under it. It's Coco. He tells her pigs need to eat too, he tells her she's a real pretty woman, he tells her he can tell she's got a nice curvly shape under that robe, he says he knows what she saw the other night and dares her to act like a real woman and keep her mouth shut.

*

She pulls her robe tighter and shuts the door in his face, locks the bolt, closes the curtains, pours herself a vodka, wills herself to call Ronnie. She can't. She drinks, stares at the television, turns away. She flashes back: her face in the snow, running toward the house, Ronnie snapping off a pine bough somewhere above her, brushing over their tracks, hauling her up, her face, frost bitten and cold-sweaty, the rough corduroy of his pants as she buried herself in his lap, sobbing deep and tired as a toddler back in the heat of her home. Ronnie was gone when she woke up the next day. They haven't talked since. She reaches for the phone, but instead grabs the bottle and beelines for the bedroom, sits down in the corner of the closet, reaches up for the hems of coats and dresses. Pulls them down upon her. She'll never call Ronnie again. She wakes up to a feeble sunrise warming her cheek.

*

Convicted almost exactly 18 years to the date of David Tyll and Brian Ognjan's deaths, Coco and J.R. Duvall are charged with premeditated first-degree murder. The jury took less than two hours to decide. There was no evidence. There was only hearsay and a terrified eyewitness. Eighteen years they had gotten away clean, made dirty by 118 minutes in the jury room.

*

An anonymous source says that until 2003, the Duvall brothers got away with everything they wanted to, all on the basis of threatening to feed people to their pigs: they had done it before, they would do it again, no one would even be able to find a tooth, they said.

*

A few months after Ronnie's death, Barbara will find one of her pet rabbits in the mailbox, a note attached to the carcass: *Just a friendly reminder you never saw anything you never heard anything.*

*

Barbara's story is all too familiar: a woman, silenced by a man. A woman, living much of her life in fear, at the hands of men. On the stand, she will feel a power course through her, lifting each hair follicle, tightening each muscle—a gentle caress, this slow wave of alertness, then a glorious relief. After the trial, she'll tire as she hasn't since she was a small child: motionless, dreamless, some bland and beautiful sleep.

*

Barbara passes away four years after the conviction, a few days after Christmas 2007. Her obituary notes that her heartfelt love for animals was evident in the compassion she showed to her many pets, including dogs, cats, and birds. Barbara's body is cremated and scattered in a makeshift pet cemetery. A small, well-intentioned fence encircles the space, slowly impeded upon by lilac bushes that bloom every color: royal purple and soft lavender and snow white. Each spring their scent hangs heavy, drifting for miles.

*

When the hunter gets home he's pissed-drunk. He's been out all night and doesn't have a deer to prove it. He tries not to wander too far out the

bounds of the law: he hunts when he wants, likes a good spliff every now and again, slacks on his child support when work won't pay up, drives home drunk, but he's been driving for years, the way home a prayer he sings himself to sleep with. There are so many small ways we justify our actions. A taut line—it begins to waver.

*

Tonight, Randi will fall asleep with her hands clasped between her thighs.

*

Ronnie shushes Barbara again, he's got that desperate look in his eyes, she's seen it before. She heard it earlier when he called her from the payphone outside Linker's, begging her to come join him. So, Barbara sighs, straps on her boots, sneaks around the side of the house with Ronnie. She's a-tipsy-slipping, but the snow is fresh, so there's no crunch to their step. The stars are brutal, unrighteous in their own light. She's got a funny feeling in her gut and it's not the vodka. They sneak through the yard, burying themselves in the barrier of trees by the road. Ronnie grabs her hand; the air is cold enough that human touch is shocking. It sobers her.

*

The swing of a bat, a rush of air, a sound like a fastball hitting the umpire in his groin. Some ripe fruit with a hard rind of skull.

*

His head just disappeared, Barbara will say in her statement to the police when she finally confesses. She'll stare into her Styrofoam cup of cold coffee. She won't make eye contact.

*

It's late October 2003 and I'm in the backseat of the dull gold Chevy Trailblazer. My mother has picked me up from cross-country practice, it's late in the season when the ground begins to freeze; it's Thursday when the local paper comes. Front-page news is usually high school football or hometown heroism, the occasional car crash, arson for the insurance, local political corruption, district teachers accused of statutory rape. But this time it's bigger—an eighteen-year-old cold case closed—"BROTHERS CONVICTED IN DEATHS OF MISSING HUNTERS" and pictures of J.R. and Coco Duvall: J.R. looking surprised, tired, a shadow of something like remorse; Coco blue-eyed, expressionless.

*

After the trial, everyone says the hunters from downstate have received their due justice. David's father Arthur says, *They took my son; it doesn't bring him back, but it's something.* Brian's mother Helen says, *God answered my prayers.*

*

Helen Ognjan will drive up north shortly after the conviction. She'll park on the road and from the back seat take two white wooden crosses she painted the previous day. She'll plant them in the middle of a clearing, look around, take a lion's breath, and say a moist rosary. Then she'll get back in her car and begin the long trip home.

*

The paper says the Duvalls fed the bodies of David Tyll and Brian Ognjan to the pigs that roamed around and through the house they were living at in 1985. Barbara testifies that between the time they showed up at her door in 1985 and the time of the trial in 2003, Coco and J.R. never failed to remind her, each time she saw them: *Pigs hafta eat too.*

*

That same Thursday in 2003, as I'm sitting in the backseat of the Trailblazer staring at mugshots of the Duvall brothers, Barbara also gets the local paper. She throws it aside, walks to the bedroom on autopilot. She reaches to the back corner of her closet shelf and grabs a lockbox, the fireproof kind used for important documents: birth certificate, dog collar, father's ashes, car titles, a few outdated bonds, high school diploma, a t-shirt of Ronnie's he left at her house a few days before the last time she saw him. It's worn through, a faded gray thing pronouncing his allegiance to some band. She fingers the fabric, the peeling decal, stuffs it deep into her face with both hands, inhales. She strips to her underwear, pulls the shirt over her head, and crawls into bed.

I SEE MYSELF IN YOU

I see my first vaginas in the public library. I am in fifth grade, after school, perusing the meager art book collection small-town Michigan has to offer while I wait for my mom to pick me up. I've read all the children's collection and the YA books and I'm not really supposed to be in the adult section, but the librarians are all distracted by people trying to figure out how to "go online" and my brother is in the kiddy section playing in the carpeted cave called "The Reading Den." I grab the biggest art book, *Chicago*, a word I'm familiar with, *Judy* an addendum I'll allow. It's full of vaginas. They're just paintings, but I know. This is my introduction to *The Dinner Party*. I get a feeling in my gut, the same one I'll have that summer at Sarah's birthday party when she and Angie lock me in the outhouse, which is papered with old *Playboy* centerfolds. I return to this book often after school, hiding it in the space between shelves so no one else can take it. Years later, I pick up the same book on a campus library and flash back: a hot, roiling hunger in the pit of my stomach.

*

It turns out I wasn't seeing vaginas in that book after all. "Vagina" is one of the most commonly misused words in English language. *The Dinner Party* plates are in fact vulvar representations, which Chicago calls "central core" imagery. Even Eve Ensler, author of *The Vagina Monologues*, acknowledges that the word "vagina" is not inclusive enough but, for lack of better

options, popular culture has adapted "vaginal" as the adjectival counterpart to "phallic." Comedian Lindy West writes that "at this point in our linguistic evolution it's become a *general* term for the *general* lady-area," but that still doesn't account for the fact that we are calling female genitalia something it's not.

*

Years ago, a friend of mine was working on a coming-of-age memoir. She didn't know where to end it. One time we were running drunk through the park and stopped out of breath and sat on a bench to split a cigarette and she told me that she had begun making decisions in her life to better the writing. She realized that she could act out her own ending, take control of her narrative. She could choose to live the stories she wanted to tell. It's the proverbial toast popping out of the toaster: someone screeching, "it's just like a cartoon!" or like walking along the ocean and watching a raptor talon a fish from the water, begin to tear the flesh up on the shore, and someone behind you comes crashing through the moment with an observation: "it's just like a nature show!" We catch ourselves in the act all the time, the overstimulation of the internet, the ego and the to-do list, the need to feed ourselves, bathe ourselves, make ourselves feel productive and pretty and presentable and important, the petty hang-ups in the everyday business of being alive. We are constantly forgetting, changing, and renegotiating our own narratives.

*

Narratives are spaces we inhabit. The longer we live in these stories about ourselves, the more familiar they become. Yet we still want to rearrange the rooms, to spring clean, to change, to make things right.

*

The Brooklyn Museum dedicates its fourth floor to the Sackler Center, Decorative Arts and Period Rooms from the seventeenth through twentieth centuries, the Ingrassia Gallery of Contemporary Art, and the Schapiro Wing for visiting exhibitions, set away from the others. These rooms circle around the Beaux-Arts Court, located on the third floor, and extending to a 2.4-acre skylight on the fifth floor. When exiting the elevator or main staircase, you'll find yourself with two options: walk straight or turn right. Right leads to Decorative Arts, mostly pottery and chairs; straight leads you through a dark tunnel of furniture and video art and spits you out in the first contemporary gallery and the main entrance to the Sackler.

Two galleries feed into the Sackler Center: the Period Rooms, showcasing seventeenth- to nineteenth-century architecture from New England and the American South, and the contemporary art galleries. From 2015 to 2017, the latter displayed the exhibition *I See Myself in You: Selections from the Collection*, comprised primarily of works by artists of color: small installations, large-scale paintings, photography, sculpture.

*

If you stay the path of the contemporary, you can faintly hear a slightly dis-
torted and stripped-down instrumental version of Billie Holiday's "Strange
Fruit" emanating from a central room. There, in the middle of the floor,
a zoopoxied tree of polyurethane foam stands, deceptively realistic, in a
mound of dirt. This is artist Sanford Biggers's 2007 piece *Blossom*, made in
response to a 2006 incident at a Louisiana high school, where three nooses
were found hanging from a tree in the courtyard. In *Blossom*, the trunk of
the tree pushes through and grips around a MIDI player piano, the way a car
wraps itself around a telephone pole when run off the highway, or the way
a deer buries itself in the windshield of a truck moving too fast through
snow. The piano bench lies overturned in the dirt as if its musician, startled,
stood up suddenly and left the room. The song restarts every 18 minutes,
the keys of the instrument moving independently of force or human hand,
the sound keening through the rest of the floor, an echo of a violent elegy.

*

From this piece, if you move north, you'll enter the Period Rooms, which
also lead to *The Dinner Party*. You'll pass through a red-walled entry-
way—portraits of kids playing in the streets of the Bedford-Stuyvesant
neighborhood of Brooklyn—into a hallway of rooms, preserved behind
glass: the plantation sitting room, the plantation dining room, the galley,
the pantry.

*

Two women stand in front of *Blossom* discussing its beauty. "How fantastical!" one of them comments, with a touch of glee, before moving on. We see what we want to see.

*

The first time I see *The Dinner Party* in person, it's 2010 and I've just left Michigan and moved to New York City, keeping a promise to my fourteen-year-old self. Despite my infinitesimal restaurant experience, I want to work for April Bloomfield, a "Hot Female Chef," card-carrier in the "Lesbian Elite Kitchen Club." I'm 22: antsy and bug-eyed, sentimental and unstable. I'm not jaded yet, but I'm strong; I'm ignorant and innocent. A future yawns before me: teeth of promise, lapping tongue of desire. I go to the Brooklyn Museum alone the day after trailing at the Spotted Pig, Bloomfield's first and most famous restaurant. Someone I was infatuated with had taken me there on my first trip to the city and touched my arm as she told me about the time her ex-girlfriend threw a hot plate of ricotta gnudi in her face. "I work for April Bloomfield" felt like an important thing to say in some future room of my imagination. The trail was terrible: I didn't bring my own knives and the kitchen was so different from that of the Italian family with whom I had spent the previous five years making pasta and chopping vegetables, delivering pizzas in Silvio's low-riding Jeep Cherokee, cleaning the meat slicer. I stood awkwardly, anxious to help, to

feel like a part of something. A female line cook took pity, lent me a knife, taught me to brunoise Holland Chile. Eventually the chef told me I could leave. He said he couldn't hire me, I didn't know enough, then offered to buy me a beer. My fingers got hot as I sat on a bench outside the restaurant, fumbling loose tobacco into a rolling paper. On the train home my hands swelled, the pit of my stomach coiling into a rancid knot.

*

I've come to the Brooklyn Museum to see *Sojourn*, a Kiki Smith retrospective, which spills from the Sackler Center into the Period Rooms, through the theater housing the Sackler Center First Awards. In each room, bauble-headed papier-mâché and muslin puppet figures hover behind the glass, opaline and tumescent. I don't yet know exactly what histories belong to these rooms. I run, frantic, between them as though Smith's figures are calling me onward, creepy in their lifelikeness.

Later, I'll spend more time wandering the hallways. I'll realize these rooms are the preservation of the Southern plantation, with casual reference to the history of slavery, favoring instead the narratives of white men. The plaque for the pantry of "The Cupola House" in Ederton, North Carolina, circa 1758, a gift of the West Virginia Pulp & Paper Company, reads: "This room was probably used as a domestic office, store room, pantry and serving area. Partly as a fire precaution, kitchens in larger Southern households were most often located separately in small buildings. This practice also kept heat, cooking odors and servants away from the formal rooms of the house."

A review of *Sojourn* notes the eeriness of the exhibition's expansion into the Period Rooms, but not for the reasons one would think, rather noting that the puppets seem "the stuff of Brothers Grimm fairy tales and Charles Dickens' ghost stories."

*

The last time I visited *The Dinner Party*, I noticed that most people viewing the installation go the wrong way around the table. They start in the third millennium and wind around to the first. People tend to move clockwise, and if you assume you are entering the exhibition at 12:00, moving clockwise is moving back in time. If people start at the end, with the plates for Virginia Woolf and Georgia O'Keeffe, will anyone still be interested by the time they get to Judith or Sophia? Or Sappho or Kali? Or will people be distracted by their own narratives of what comes next, failing to acknowledge what it took to get there—all that work to build these spaces we live in.

*

But there: an amorphous puppet canted upright on the stairs—upheld only by a string around its neck. A sleep never-ending. The curator of Kiki Smith's retrospective says of *Sojourn*'s intrusion into the Period Rooms: "The notion of space has a particular resonance for women artists throughout history. Their artistic impulses have long been constrained." But there:

another spectral figure with a cane, oversized head, sitting up between the curtains surrounding the bed. Across the narrow hallway, a plaque naming this the stairwell and sitting room of the Henry Trippe House circa 1730 in Secretary, Maryland. Trippe's accompanying biographical statement reads: "At his death in 1744, Trippe owned a considerable amount of silver and a modest library of more than 50 books as well as 18 adult and 13 children slaves." Each narrative deserves a room of its own.

*

Critic Peggy Phelan writes in "Broken Symmetries: Sight, Memory, Love:" "The relationship between representation and identity is linear and smoothly mimetic. What one sees is who one is. If one's mimetic likeness is not represented, one is not addressed. Increased visibility equals increased power." This is true of gender, race, class, social status. This is true of age, idea, ability. This is true of politics, of ethnicity, of sexuality. This is true of memory.

*

Included in the exhibition *I See Myself in You* are life-size plaster casts of John Ahearn and Rigoberto Torrès's friends and neighbors from the South Bronx during the 1980s. Ahearn and Torrès's work tracks, reveals, and presents a particular social and economic challenge: note *Titi in Window*, positioned in the upper third of the wall. It's a six-pane window, slid open.

A woman with a kind face, a blue apron and white shirt leans between yellow curtains and over the cement sill. She glances down at the viewer, exhausted and deep in thought, resting her cheek on her hand. Initially, Ahearn and Torrès hung these casts on apartment buildings around their neighborhood.

There's Theaster Gates's series *In Case of Race Riot II*: decommissioned high-pressure fire hoses coiled like snakes inside vitrines set in the wall. Deana Lawson's photograph "Hellshire Beach Towel with Flies" evidences only a pink towel on a pink chair, suggesting violence in the absence of a body. An entire wall is dedicated to pieces from Titus Kaphar's *Jerome Project (My Loss)*—large-scale portraits of people who share Kaphar's father's name and who, according to government databases, also are or have been incarcerated. Each portrait is intricately painted in oil and gold leaf on wood, then dipped in tar to reflect the length of the sentence—how much of this life has been claimed by the prison industrial complex. The tar often covers the figure's mouth, sometimes reaches the nose, sometimes hits at the brow line—a deep, textured interruption—a silencing.

*

Art makes visible the narratives in which we live. The narratives we reject. Art is what happens in the space between the piece and the viewer. History is what happens in the space between society and the story. Chicago made *The Dinner Party* in the ebb of second wave feminism, which revolved around the domestic role of women, more accurately, the domestic role of

white, middle-class women. A history that ignores entire groups of people is no kind of accurate history at all.

In 1983, four years after *The Dinner Party* premiere, Alice Walker's collection *In Search of Our Mothers' Gardens: Womanist Prose* is published. In the preface of the book, Walker defines a "womanist" as "a black feminist or feminist of color." Her second definition is, "A woman who loves other women, sexually and/or nonsexually. Appreciates and prefers women's culture, women's emotional flexibility… and women's strength." Her fourth and final definition is an analogy: "Womanist is to feminist as purple is to lavender." Walker creates a more inclusive space, broadening the narrow terms of the feminism from which Chicago's art was born. The next year, in 1984, bell hooks publishes *Feminist Theory: From Margin to Center*, in which she writes that, "After constructing feminist theory and praxis in such a way as to omit focus on racism, white women shifted the responsibility for calling attention to race onto others."

Chicago was a product of a whitewashed feminism, and thus *The Dinner Party* is a product of a limited point of view. Ten years after the premiere of *The Dinner Party*, scholar Kimberlé Crenshaw coined the term *intersectionality*. She writes that, "the intersectional experience is greater than the sum of racism and sexism," and thus any analysis, or any art, that doesn't consider intersectionality will never be inclusive enough. We cannot preserve what we cannot see. All representation leaves something behind. It's up to us to pick up the leftovers.

*

The America Play, written by Suzan-Lori Parks in the early 1990s, is set in "a great hole. In the middle of nowhere. The hole is an exact replica of The Great Hole of History." In the second act of the play, the character of Lucy says to her husband, The Foundling Father (an African American Abraham Lincoln impersonator), "You could look intuh that Hole and see your entire life pass before you. Not your own life but someones life from history, you know… someone from History. *Like* you, but *not* you. You know: *Known*."

*

The second time I see *The Dinner Party* is a few months after the first. My mom is visiting and I want to show it to her. At this point, I'm helping April Bloomfield open a new restaurant—I'm shucking hundreds of oysters every night. Some nights, thousands. In the Brooklyn Museum, I stand at the first wing of the table and try to explain to my mother the significance of the piece for me, but also for her, for the both of us. I can tell she's uncomfortable. I don't want her to be, but I also really want her to be. At the intersection of discomfort and discovery, we can have a dialogue. I want her to find something of herself, something of what I am becoming, having come from her. Afterward we split a goat curry at a Caribbean restaurant whose second floor is shaped like the upper deck of a ship. We make small talk. After another glass of wine, she tells me she's living a life she didn't quite expect, not the life she told herself stories about when she was younger.

Instead she's trapped in a different sort of narrative. She tells me that real love and true love are very different: one lasts and one persists; "real" being flecked with forever, and "true" being studded with time. Interpretation happens in this space between the speaker and the audience; love between the giver and the taker.

<p style="text-align:center">*</p>

It goes like this: while I'm living in New York City, my mother always visits me in times of heartbreak.

It goes like this: I'm standing in front of Josiah McElheny's *Endlessly Repeating Twentieth Century Modernism*, in the same gallery as *Blossom*. The piece is a mirrored box containing eight hand-blown mirrored objects—reflected everywhere and endlessly, repeating into infinity, into darkness. My own eyes, in triplicate, go on forever, smaller and smaller as they recede.

It goes like this: Judy Chicago tried to make *The Dinner Party* all by herself, then she realized it was an impossible task. Her mother began to help her, soon after accompanied by another 129 volunteers.

<p style="text-align:center">*</p>

In "The Joy of Creating," a craft essay about the meaning and making of

The Dinner Party, Chicago writes that since the inception of the project she has "steadily expanded [her] gaze, gradually widening [her] perspective on the oppression of women symbolized by *The Dinner Party*, until [she] understood it in a wider global context of injustice, inequity, and vast suffering—for both human beings and many other species."

*

And through the doors, the Period Rooms—to spread these histories out along one plane, to encounter them in the same time-space continuum. The dining room of Cane Acres, The Perry Plantation from Summerville, South Carolina—if we were standing in this room in 1820, a representative painting tells us, we would be seated at a long wooden table surrounded by old white men drunkenly sloshing their wine glasses on the fine linen, a black male static in the corner with a towel over his arm. The unreeling of these tightly tucked narratives sharing space on the fourth floor of the oldest museum in Brooklyn, with space at the center to plant the bulb of a new story.

*

On a formal tour of *The Dinner Party*, a nanny whispers the names on the runners into the double stroller she pushes. A young boy runs his hand along the bar separating the table from the viewer. Imagined partition—he

reaches out and touches a plate. Hypatia: brutally murdered for refusing to shut her mouth. One lover says to the other, "We have a vulva coming up on the left," arms encircling waists. One woman says to another, "Am I rejecting my own body because I don't think this is necessary?" Tourists giggle and take pictures with their iPhones, the older men shrug or blush, or catch themselves somewhere between a shrug and a blush. Toward the end of the tour, an older woman interrupts Rose, our tour guide, and asks: "Why does that plate look like a vagina?" Rose responds, "All the plates do." The woman puts her hands on her hips and shakes her head, defiantly, saying, "Not to me, they don't."

ORIGINS

When *The Dinner Party* premiered in 1979 at the San Francisco Museum of Modern Art, it met a tough crowd. The male director of the museum announced that it was the culmination of Chicago's career, when in actuality it would turn out to be only the rising action. Critics cited *The Dinner Party* for its lack of diversity and particularly for the second-waviness of the feminism it represented. bell hooks notions this as "past feminist refusal to draw attention to and attack racial hierarchies" which "suppressed the link between race and class."

Chicago's criteria for inclusion in *The Dinner Party* required that a woman had made a worthwhile contribution to society, tried to improve the lives of other women, had a body of work that epitomized significant aspects of women's history, and provided a model for a more egalitarian future. Yet by lifting certain forgotten women up, *The Dinner Party* pushed other forgotten women further into the margins. Chicago's installation was challenged for its underexposure, its overexposure, its failure to judge properly the aperture, the installation a little too blind to its own use of light and shadow.

*

After walking through *The Dinner Party* for the first time, Alice Walker published an essay in *Ms.* magazine lauding Chicago for her audaciousness

and nerve. But something didn't sit right with Walker. She couldn't get around the uncomfortable oversight in representation. "It occurred to me," she writes, "that white women feminists, no less than white women generally, cannot imagine black women have vaginas."

Walker speaks of Chicago's place setting for Sojourner Truth, the sole African American woman in attendance. Truth's plate shows a three-headed women. A single tear leaks from the eye of one face, another open-mouthed and sharp-toothed in rage, the eyes black slits encircled by white lids. A mask decorated with black-and-white triangles is sandwiched between these faces. The Brooklyn Museum's website notes that this central face is meant to suggest "the extent to which both black and white women were required to conceal their true selves." This is only plate that doesn't have vulvar connotations, whether of the abstract or floral or entomological variety. Walker eventually conjectures this semiology: "Better then, to deny that the black woman has a vagina. Is capable of motherhood. Is a woman." She couldn't find her place at the table.

When I bring this idea up to a gallery tour guide in fall of 2014, in the wake of Ferguson and the emergence of the #BlackLivesMatter movement, she'll bluntly say: "Well, Chicago wasn't speaking to world history. She was working with the history of the Western world." The rest of the people on the tour sort of nod, obligingly. I inquire further about the Western world—the tour guide stops and turns around to look to me, pointing to a plate with a geometric, earth-toned pattern, sitting atop a deerskin runner: "What about Sacajawea? She's a woman of color, right? What do *you* think?"

Amelia Jones concludes her essay "The 'Sexual Politics' of *The Dinner Party:*

A Critical Context": "I count myself, a white feminist, among those Walker accuses of a certain blindness. Those of us who have benefited from being white—like Chicago, like myself—tend to see race as an aspect of our femininity." I don't think I see my whiteness as absolving me of gender, or my gender as absolving me of whiteness, but I do acknowledge that being a white woman means I have an inherent privilege. The old lifeboat slogan of women and children first—or, (white) women and children, please step in. We can save you. We will save you. This is a problem we can diagnose with our own eyes. Authority is required to dismantle institutional racism, but only individual accountability is needed to recognize these singular acts of blindness, and make the requisite changes.

*

Here's what I think: Chicago was acting, albeit imperfectly, upon a deep cultural hunger, a quarrel of gender and renown. There are cracks. She saw a gap to fill. More gaps emerge. We see those rifts. We try to fill them.

*

Peggy Phelan muses: "What is required in order to advance a more ethical and physically rewarding representational field, one that sidesteps the usual traps of visibility: surveillance, fetishism, voyeurism, and sometimes, death?" She continues: "How are these traps more or less damning than benign

neglect and utter ignorance?" We get so myopic that we forget. We're so myopic in our collective dissociate fugue. What of the traps of visibility? What of the mirror in which we fail to appear?

In *Redefining Realness*, a memoir of her life as a trans woman, Janet Mock writes: "I believe that telling our stories, first to ourselves and then to one another and the world, is a revolutionary act. It is an act that can be met with hostility, exclusion, and violence. It can also lead to love, understanding, transcendence, and community."

These are not my stories, but these are not not my stories either.

*

For the rest of that particular gallery tour, I think about the vaginal imagery of the plates. I think of my place in this space. What a privilege it is to feel seen. I'm reminded of what Judy Chicago says: "I think what's important is to give space to the range of human experience." Chicago breathed new life into these particular women's histories. They now have space. I think of desire: to be seen, to be heard, to be touched, to be felt. I think of what Jamal Lewis wrote in a *New York Times* opinion piece: "Sadly, when trans and gender-nonconforming people experience violence at the intersections of race, class, gender and sexuality, we are often blamed for our deaths. Some of us live and thrive because we are desired; none of us should die because of that."

*

On my next trip to the Brooklyn Museum, the rest of the Sackler gallery is shocked into violence under fluorescent lights. Zanele Muholi's exhibition *Isibonelo/Evidence* documents the black lesbian and transgender communities of South Africa over the last decade. The black and white portraits are poster-sized, hanging three by six along sections of the gallery wall. Every face is challenging, beautiful: they wear hats, hoods, lip rings, sashes, and suitcoats. They cross their arms, they face the camera straight on, they put their hands in their pockets, they cross hands over their stomachs. There are few smiles. Each face wears an expression of pride. The portraits are witness to an exceptional strength. Muholi interviews her subjects about identity and fear. In an accompanying monograph, *Faces and Phases*, each of her subjects shares their story.

Another wall in the same gallery documents dozens of rapes and murders of members within this same community. Muholi explores the intersections of queerness and blackness in South Africa, where those identities are especially targeted. Statistics are listed on a large wall of the gallery. It's heartbreaking, overwhelming, and serves as a call to action. In a review of the exhibition Muholi describes herself as a visual activist. *Isibonelo* means "example" in Zulu. She considers each photograph in the series "an example and part of the growing historical record." Muholi says "the preservation and mapping of our herstories is the only way for us black lesbians to be visible."

These traumas are presented alongside the iconography of community ritual: video footage of LGBTI couples making love, marrying, partying,

celebrating. In the center of this room, Muholi's own likeness is framed in a flower-sprayed glass coffin. A marker of time and distance. We must make room for everyone to tell their own stories. In the gallery, there is a blank wall. Sidewalk chalk. Everyone who visits is asked to share their story. Muholi makes a space.

*

In November 2014, Lolita "Cookie" Smith tells a local paper that her granddaughter, a missing transgender woman of color, was "not given a drop in the bucket of what other people got," in reference to the media coverage of the case. She continues: "I can't see how one person's life is more valuable, regardless of skin color, sexual orientation or ability to pay."

In February 2015, an article in the *Washington Post* quotes Natalie Wilson, the co-founder of the Black and Missing Foundation, who says "[FBI Statistics show that] 40% of people who are missing in the United States are minorities, but they don't receive nearly the same amount of media coverage."

According to Mic.com's *Unerased Project: Counting Transgender Lives*, a comprehensive, interactive database tracking transgender homicides since 2010, "if, in 2015, all Americans had the same risk of murder as young Black trans women" there would have been approximately 104,400 more homicides in the United States that year. The statistics on the database show that young black trans women are "between 8 and 39 times more likely to be murdered than young cisgender women."

An article about the project in *GLAAD* notes that the count may be inaccurate because "the identities of transgender victims are often erased or effaced after death." Meredith Talusan, the lead journalist for the database notes that, like a public health crisis, "the epidemic of transgender murder" can't be understood until it's accounted for, until the crisis is no longer ignored by the general public, officials, and institutions at the state and national level.

*

Back in the gallery, I begin to see. I begin to see shimmery figures around the table, these echoes and shadows, translucent apparitions appearing between the plates. All these forgotten women. All the women shadowed behind them. All these gossamer hands reaching up and out of the void. All these ghostly mouths keened open, ready to speak, to announce their desires. To say their names. I see their names simmering up from the chalices. I try to understand who needs to be heard. I say their names. I try to see everything. I try to approach it.

*

Coda

When the Primordial Goddess sits down to dinner, she feels a strange energy emanating from the expanse of the room, the vibrations of the table—

something about to give way. Her feminine energy an impetus, the catalyst.

When Trisha Lopez disappears, she's a mother of two; acquaintances tell the police her distinguishing characteristics are a tattoo of a butterfly under her left eye, a tattoo of a spider on her neck.

When the Fertile Goddess sits down to dinner, she feels small, faceless, venerated. She begins to swell: her breasts, her belly, her hips, her vulva.

When Holly Bobo disappears in 2011 from her family home in Tennessee, she had last been seen alive by her brother. He saw her walking into the woods with a man wearing camouflage. She was studying to be a nurse. The media leaps, and over time six men are arrested in connection with the case.

When Ishtar sits down to dinner, some dismiss her as a hot-headed femme fatale, while others revere her for those same traits. She becomes the circumscribed personification of warfare. She determines and enacts her own power through sexual congress—she the one who determines the fate of the priest and the king. She transforms men into women.

When Lauren Spierer goes missing in 2011, she is wearing black leggings, a white shirt, and no shoes. Surveillance footage from Bloomington, Indiana, proves this. Her family continues to offer more money for any leads as to her whereabouts.

When Kali sits down to dinner, she fills her chalice with blood and envisions throwing her china across the room. Just to watch it shatter. Just to feel it break. She doesn't even really belong here, being of Eastern descent.

She controls both life and death, bringing them together, dancing upon the body of her counterpart god.

When Crystal Grubb disappears, the year before Lauren Spierer, into the same landscape, her friend laments that, "it was in the newspaper like once. For Spierer's disappearance, everyone's here and there's posters everywhere, people walking around. Definitely nothing like that was afforded Crystal. I don't want to say it's because she was of a lower economic class, but that's what it seems to me." Grubb had two daughters. Another woman from Bloomington puts together a remembrance gathering for her, and includes Spierer as well. In a post on her blog, she says that, "as a parent living here, they're both always on my mind."

When the Snake Goddess sits down to dinner, she feels incarnate those who came before her and those who are to follow. She finds her own way to the table, ensuring the protection of others. She solves problems through venom-induced trances, men her subordinates.

When Natalee Holloway disappears on her high school graduation trip in 2005, her parents call for a boycott of Aruba. They appear on every major television network talk show. The governor of Alabama convinces other states to join the boycott. Soon after, a reporter from El Diario *comments that "the English-language media… appear to be focused on the stories of missing white women… cases of missing Latina and African American women often remain faceless, when they are even covered."*

When Sophia sits down to dinner, she brings with her the supreme flower of light. She understands, as the Virgin Mary before her, this mystery of life. The feminine needs of god emanate around her.

When Tamika Huston disappears in 2004, almost exactly a year before Holloway, her family tries intensely to generate media interest, but no one seems interested. The police say there's no indication of foul play. They find her dog left alone in the apartment, recently having given birth to a litter of puppies. Her friends and family say that because of her love of animals, she would never intentionally leave them untended without water and food.

When Amazon sits down to dinner, she comes not by nicety of invitation—she comes to invade and conquer. She's fueled by a confidence found in unfettered feminine power. Her breasts hang low, nipples golden in the sun. She teaches these women how to use their bodies for physical defense, how to take pride in their sex, and to love themselves first.

When LaToyia Figueroa goes missing, she is five months pregnant. She didn't show up for work. This is a year after Laci Peterson, a white woman eight months pregnant, goes missing, and though their cases bear many similarities, the news coverage doesn't compare. This is a few months after Holloway's disappearance in 2005, and CNN, MSNBC, and Fox News all neglect Figueroa's story, using the airtime to continue to cover and repeat the circumstances of Holloway's case. In response to this inaction, a duo of rap stars funds an America's Most Wanted *reward for information about Figueroa's disappearance.*

When Hatshepsut sits down to dinner, she isn't afraid to walk home alone, at night. She herself a pharaoh—she rules her own land. She prefers frankincense and myrrh, a peaceful foreign policy under her command. The sphinx bears her likeness, the beard a symbol of her power.

When Morgan Harrington goes missing, after getting locked out of a Metallica

concert due to the arena's "no re-entry" policy, the band donates $50,000 as re-ward to anyone with information about her disappearance.

When Judith sits down to dinner, a powerful perfume wafts up from between her legs: the scent of fresh blood, of severed flesh, of open wound. She brings secrets with her, and strength. A village rests on her shoulders. This is her sacrifice.

When Alexis Jones-Rhodes goes missing, her family gives pictures of her to the police, but it doesn't make much of a difference. They say they are too booked to accommodate the request without more evidence of foul play.

When Sappho sits down to dinner, she thumbs her nipples and licks her lips. She feels like singing a powerful song. Sappho believes that everyone has the right to love who they love, worship who they worship, be who they are. She believes everyone has the right to exist on an island of their own creation, that it's no one else's business. For this, the church labels her criminal.

When Kedarie Johnson disappears, the entire city mourns. Kedarie's mother Kandace says, "He was accepted by everyone"—rambunctious, popular, fun-loving, gorgeous. Kedarie liked to wear women's clothes, make-up, wigs, maxi skirts, false eyelashes. Kedarie didn't have a preference among pronouns, preferring to be fluid in gender. Sometimes he went by Kandicee. He was happy, always, with everyone. Video surveillance from the Hy-Vee grocery store where Kedarie was last seen alive shows him dancing in and out of the frame, coaxing his friends to join. The case was not initially treated as a hate crime, until a federal investigation began.

When Aspasia sits down to dinner, she comes literate, unmarried, free. She wants to dialogue with these women, say their names, hear their thoughts. Rumor has it she kept a brothel. Some historians say, "to ask questions of Aspasia's life is to ask questions about half of humanity."

When nine-year-old Amber Hagerman goes missing in 1996, an AMBER alert system is developed by local police as an early warning tool to help find abducted children, which soon developed into a national strategy. The recommended criteria are that there is both "reasonable belief by law enforcement that an abduction has occurred" and enough "descriptive information about the victim" in order to assist the recovery. Notifications are immediately sent to major carriers and broadcasting networks to run on television, radio, and send via text.

When Boadaceia sits down to dinner, she comes to ensure the potency, virility, and fertility of her land and people against colonists. Soldiers capture and bind her, force her to witness the rape of her two daughters. She says, "You will see that in battle we must conquer or die. As for the men, they may live or be slaves." And so here she sits, willing to sacrifice herself; she comes willing to drink the poison rather than give up her seat.

At the time Rilya Wilson goes missing, she is living under the care of the state of Florida. Her disappearance isn't noticed for two days. In response to the oversight, an eponymous alert for children of color is put into place. The press statement for its initiation explains that "often the assumption is that the white girls are quote-unquote innocent victims whereas with poor children or children of color, [it's assumed] there's some nefarious activities involved." The RILYA Alert serves missing children of color under the age of seventeen. It doesn't take the place of an AMBER Alert, but has fewer restrictions. All missing children of color who receive

an AMBER Alert also receive a RILYA Alert, but not all cases qualifying for a RILYA Alert meet the criteria for an AMBER Alert. This system notifies the public when a child of color goes missing in cases where an alert would not be issued otherwise, increasing the chances that the child is found and safely returned.

When Hypatia sits down to dinner, she intends to construct an intellectual reawakening of reverence for the goddesses. She believes our religious figures should be feminine. That the Mother Goddess would keep men from misusing their women so that future generations might be born out of love, rather than force. Eventually, she'll be mistaken for something other than a goddess—her limbs will be pulled from their sockets, her organs plucked out, her torso hacked to pieces and set on fire.

When Relisha Rudd disappears, she's living with her mother and sister in a homeless shelter. Her mother insists that the community step up: Relisha is everybody's child. A dozen Facebook pages dedicated to finding her are created, but beyond that the media barely takes notice.

When Marcella sits down to dinner, she believes that in Christ she is neither male nor female, that all genders have equal rights. She is beaten to death.

When Hannah Upp disappears, she's jogging Riverside Drive just south of the George Washington Bridge. She is due to start teaching the next day. A few days later, she is seen checking her email at a Tribeca Starbucks. A few weeks after that, a ferry driver finds her floating face down, alive, in the Hudson River. A psychiatrist will diagnose her with dissociative fugue, explaining that "we tend to experience our identity as a thing, as if it's a constant." It's not. The authorities never suspect her of criminal activity or intent.

When St. Bridget sits down to dinner, she carries an acorn under her tongue. When it germinates in the warmth of her salivary flora, she will build herself a shrine made of oak.

When Barbara Dreher disappears, authorities presume she's involved in criminal activity, as she often went to visit her estranged husband in a neighboring, less-esteemed town. After leaving her job as superintendent of a local public school, she drops her grandchildren off at her daughter's house so she can cash her paycheck. She is abducted instead. Later, the police find her car, and in it: gloves, a ski mask, and a rope, in addition to her personal property. The man who was found driving her car is never brought in for questioning, nor charged.

When Theodora sits down to dinner, she insists that those who act—without shame, without fear, without trepidation—deserve to be free. After she leaves the theater, she makes it illegal to force a woman into prostitution, and legal for women to inherit property.

When Kortne Stouffer goes missing, they find her keys, wallet, cell phone, and shoes. They never find her living room rug, her Chevy Tahoe, or her dog. She had already called 911 twice that night.

When Hrosvitha sits down to dinner, she announces that women deserve the chance to destroy what they create, if they so choose. She believes men to be the embodiment of lust and evil, that misogyny must be challenged. She clasps her hands around the scroll.

When Ramona Moore disappears in 2012, she had last been seen entering her apartment to get a mango for her neighbor. She had already called 911 twice that day.

When Trotula sits down to dinner, she believes that, despite the curse of Eve, women need not experience any unnecessary pain, even in childbirth. She doles out opiates to those around her.

When Romona Moore goes missing in Brooklyn in 2003, the police are busy looking for a white, middle-aged man who disappeared from his rare books shop in the Upper East Side around the same time. The police misspell Romona's name in the report. During that time, she is held captive and tortured. The police reject her mother's repeated requests to find her daughter by saying she is "probably off with her boyfriend."

When Eleanor of Aquitaine sits down to dinner, she has already been imprisoned for sixteen years at the hand of her husband. She reveres the gentle religion of the heart, wishing to care patiently for those around her, a unicorn in captivity.

When Alexis Patterson disappears, she's wearing a red hooded pullover. She walked to school, less than a block from her house, but never attended class. When her parents are notified later that evening, the areas immediately surrounding the school are searched. Later, it is suggested that her parents were potentially connected to the case, but this is dismissed when authorities decide that their past criminal records have nothing to do with their daughter's disappearance.

When Hildegarde of Bingen sits down to dinner, she seems mystical, otherworldly, augural. She is one of the first at the table to describe the transcendent experience of the female orgasm. Radiating around her a ring of reparative, ethereal light.

When eight-year-old Sandra Cantu goes missing, she's playing at a friend's house after school. She never comes home for dinner. Her body is discovered in a suitcase that surfaces from routine drainage of a nearby irrigation pond a few weeks later. Her Sunday School teacher, who reported a missing suitcase within twenty minutes of Cantu's estimated time of death, wasn't initially a suspect because she was a woman, white, involved with the church. At her sentencing, she says: "I wish that I could give you an explanation for what happened."

When Petronilla de Meath sits down to dinner, she has been accused of making animal sacrifices, cooking her meals in a skull, concocting secret potions, rendezvousing with the devil. She's eventually imprisoned, tortured, then burned alive by those who operate under the statute that women are guilty until proven innocent.

When Caylee Anthony goes missing, the media pays more attention to her mother Casey: a young, white, beautiful, blue-eyed brunette. Casey continually blames a neighboring Hispanic woman she claims was Caylee's nanny. This woman had, in fact, never met the Anthony family. A Lifetime movie is made about the case, starring a young, white, beautiful, blue-eyed brunette as the mother. Casey Anthony is acquitted of all serious charges. Eventually, they'll find Caylee Anthony's body buried behind her maternal grandparents' house.

When Christine de Pisan sits down to dinner, she ferociously counters vicious attacks on the female sex made by men in high places. She speaks forcefully, with an elegant outrage. She imagines a new world, a city of light, where women are appreciated and respected. She begins to catalogue the contributions of women before her, so that they may not be forgotten.

One late summer evening Laura Arroyo answers the door of her family's home and never returns to the sitting room. A few weeks later a crowd of 10,000 gathers around an empty billboard, where it's said she appears nightly: her face a flickering apparition upon the white plastic background. Within a few weeks, the local police paint over the billboard in order to subdue the crowds.

When Isabella d'Este sits down to dinner, she takes control of her troops; she writes thousands of letters debating love, politics, war to the prominent scholars of the time. She has been allowed to be educated. In this way, she helps to shape history.

When Elisha Walker goes missing, the police incorrectly identify her as male. She was always trying to make people laugh; she was about to move out and live with a friend; she was last seen with her lover who had no idea that she was a trans woman. The missing persons report is filed away. A few blog posts are made. A few people share it on social media. The police report still reads as a cold case, and under gender of missing person she's still listed as male.

When Elizabeth R sits down to dinner, she wears a forest of fabricated ruff covered with a cloth of gold. She fights in favor of relief for the old, the infirm, the poor. She speaks up for those wrongly convicted. She doesn't believe in keeping house as a sign of respectability.

When Amber Monroe disappears, the police intentionally use the wrong pronouns to refer to her. A friend says, "if somebody is looking for us... we're not going to get found in a timely manner because they misgender [us]." Amber was always excited to learn, and she wanted to teach. She wanted to educate the larger

African American community about what the trans community was up against. She wanted to teach empathy.

When Artemisia Gentileschi sits down to dinner, a hole inside her begins to knit itself shut. She stares at Judith across the table, a warmth flooding her, like that of which Hildegarde had sung.

When Hannah Graham, an eighteen-year-old University of Virginia student, disappears in 2014, the City of Charlottesville donates $10,000 to her search within just a few days.

When Anna van Schurman sits down to dinner, she shows her full face with pride, smiles seductively, shakes out her hair. She's so used to being hidden in rooms of men, her face behind a curtain, the only way she was allowed to learn. She gets a little drunk, laughs with abandon.

Sage Smith, a nineteen-year-old transgender woman of color, disappears in 2012. The City of Charlottesville offers to donate $10,000 to her search, but not until the fall of 2014, a week after donating this amount to the search for Hannah Graham. City officials claim the two-year delay resulted from a misunderstanding.

When Anne Hutchinson sits down to dinner she has been excommunicated; banished from her community. At this table, she is welcomed with open arms. She is welcomed home.

The day before Tara Grinstead disappears from her hometown in rural Georgia she attends a beauty pageant, then an evening barbeque. When she doesn't show up to her high school teaching job the next day, her coworkers call the police, who

find her car unlocked, her purse and keys, a latex glove outside the house, her cellphone sitting on the kitchen table. Eleven years later, a young white man will make a hit podcast about the case, hoping to solve it. Before the final few episodes air, two men are arrested in connection with her murder.

When Sacajawea sits down to dinner, she has been hired by men to nurse and forage and prepare and mend and heal and break trail. She has no way of knowing, at the time, what grief she married into, that her assistance would lead to the slaughter of her own people by the men she accompanied. At this table, she finds solace.

When Unique Harris goes missing, no one but her family and friends know, despite numerous calls and police reports, until the Black and Missing Foundation shares the details of her disappearance with a wider audience—those caring to listen. Her son has a mole above the corner of his mouth, just like his mother did. Her other son has her playful attitude. Unique's mother still hopes she'll come home—and the hope is unbearable.

When Caroline Herschel sits down to dinner, she has given up her passions, determined to quest among the stars anew, and alone. She wants to part the ceiling, show off her skills—a comet in a hazy cloud of light. She is the first woman to be made an honorary member of the Royal Astronomical Society.

When Jhada Clark goes missing, she isn't officially searched for until Michael Baisden, an African American talk show host, begins a partnership with the Black and Missing Foundation, giving her story the national attention it deserves. She's returned to her mother a month later.

When Mary Wollstonecraft sits down to dinner, she insists that the tyranny of men be shattered: politically, socially, domestically. A "hyena in petticoats," she takes her chair. She has come for vindication. "It is time," she says, "to restore women their lost dignity and to make them part of the human species."

When Ashley Sweeney goes missing in Detroit in 2008, the police eventually find her body in an empty lot. They refer to her as a "man in women's clothing" and say that she "was probably just a prostitute." They didn't find out her age; not much else is known about her. A decade-long list of fatalities attributed to gender-related hate crimes published on Transgender Awareness Day later that year notes they do "not include victims that were unreported" by the media. Each biography is written in the first person and contains a picture, if possible.

When Sojourner Truth sits down to dinner, she is too aware she is the only black woman present. She poises herself proudly as a symbol of the struggle for freedom—but "there must be something out of kilter." She explains the idea of intersectionality, and those around her begin to weep at the twinning natures of oppression. She already knows she won't stay long.

Yaz'min Shancez is known as Miss T to her friends. When she disappears, the police use the wrong name and the wrong pronoun. So do most of the newspapers. They refuse to consider this a hate crime, saying that a hate crime is "killing someone for a specific reason." When the community holds a vigil, over 200 people show up. Her aunt says this means so much to her because she "never knew so many people could love a person like that." Her friends and family say that Miss T loved the color black, that she loved to style hair, that she never forgot to say "I love you."

When Susan B. Anthony sits down to dinner, she begs: please, regardless

of race and gender, the temperature in the room is quite pleasant, shan't we all agree on that to begin? She argues that only through unity can equality among genders be achieved.

When Athena Joy Curry disappears in 2011, a YouTube video surfaces, pleading: "we are begging for your help, since the media won't." Curry has a young child. The police are notified. Authorities make few attempts to find her. "Her name is not Natalee Holloway or Casey Anthony… HER NAME IS ATHENA CURRY and we need YOUR help finding her." There are no leads in her case. The video has since been disabled by the site due to "questionable user content."

When Elizabeth Blackwell sits down to dinner, she wants to talk about sex and bodies and health—of being and spirit. She thinks she stands alone, and soon realizes that here at this table she sits, but certainly not alone. Finally, she has found not ostracism but respect for her ideas.

When Kandis Capri goes missing in 2015, she is a social butterfly, studying theology, finally living comfortably as a woman with a beautiful circle of family and friends. Her home state of Arizona protects her rights on the basis of sexual orientation but not on the basis of gender identity. Twenty states do not address hate crimes based on either. Her family calls for the Department of Justice to step in. Over 500 people attend her funeral to show their support.

When Emily Dickinson sits down to dinner, she enjoys the social activity. All these women. She grasps the hands of those around her.

When Islan Nettles disappears, she has just started living publicly as a woman, gotten a job in retail, moved into her own apartment, and started her own fashion

line. Her friend says, "She was finally going to start living her life." The man who beat her to death on the sidewalk says that she threatened his masculinity. He pleads guilty in exchange for a plea deal.

When Ethel Smyth sits down to dinner, she begins to write on her placemat but stops, turning her attention to the dire prejudices held against them as women. She knows music can bring them together. While imprisoned, she conducted compositions with her toothbrush. She begins to play a song. After the meal, her fellow guests dance the march of women atop the table.

When TeeTee Dangerfield goes missing in Atlanta in 2017, she is the sixteenth transgender woman known to be murdered in the US that calendar year. She had just bought a house, she was incredibly loyal, she was known as a great negotiator, and got a union started for her coworkers. She made a home with those around her. Her friends say, "She was wonderful. She was never uncomfortable with herself. She was a queen. Marvelous." She was killed just days after a comedian says on "The Breakfast Club," a popular morning radio show, that if he discovered a woman was transgender he would kill her. The interviewer later condemns the comments, but the comedian stands by them, saying, "I got a problem with somebody trying to take something from me."

When Margaret Sanger sits down to dinner, she wants to revel in the company of rebels. A rebellion of women with go-to-hell eyes warm with whiskey and wine. Because of her, the women who follow will have options for their own bodies—reproductive rights, a freedom before unknown.

When Mya Hall disappears, she's written off as troubled, a prostitute, as a "man

in woman's clothing." She was shot by police, and misgendered in every major news story. A blogger will write in response that "more women will be reminding us that the lives of black women, black transgender women, and sex workers matter just as much as those… who are frequently at the center of the media's attention." But that reminder shouldn't have to come through death.

When Natalie Barney sits down to dinner, she pulls out a tobacco and a pipe, lights it, and passes it around the table. She believes in being a friend to men, but a lover of women.

When Mercedes Williamson disappears, she's only seventeen. She's been sleeping on her friend's couch in Alabama after her family kicked her out of their home. After they find her body in a remote field, the police say they don't have a clear motive for her murder. The man she had been seeing had just found out that she was transgender, after which he beat her to death with a hammer. The director of the Free2Be Anti-Violence Project says: "In a state like Alabama, where politicians are trying to pass legislation to institute discrimination, that gives some of the population the feeling they have permission to be violent."

When Virginia Woolf sits down to dinner, she doesn't quite understand how she got invited to a specifically female affair, as she doesn't feel she inherently fits the parameters of being female. Gender, for Virginia, follows a different pattern. She almost leaves the party, but stays, beginning to weave together the thrumming natures of tripling injustices.

When India Clarke goes missing in July 2015, the detective refuses to use her correct pronouns. He says, "We are not going to categorize him as a transgender. We can just tell you he had women's clothing on at the time. What his lifestyle was

prior to that we don't know—whether he was a cross-dresser, we don't know."
But we do know. India had fully transitioned, and only used female pronouns.
She was studying to be a cosmetologist. She had been living as a woman for years.

When Georgia O'Keeffe sits down to dinner, she refuses to understand anything at all other than the line, color, and tonal contrasts of her own place setting. She doesn't understand why she was invited; she insists she does just fine on her own.

When Shade Schuler disappears, she's misgendered by the police. A close friend in
her trans community posts on social media sites: "Stop fucking killing us."

NONE OF THIS MAKES IT INTO THE STILL LIFE

In 2002, a long-delayed exhibition of father and daughter Italian Baroque painters Orazio and Artemisia Gentileschi opened at the Metropolitan Museum of Art. The curator told the *New York Times*, "with Artemisia, there is always an attribution problem, because she adapted so quickly… she was a realist, she was pragmatic. You can't help but admire a woman who was really out there." Discussing her in relation to her father and other famous painters of the time, he continues, "One of the historical distortions about Artemisia is that she was unique," he argued, "[but] that is not so. It is the style that makes the art look more biographical." Artemisia, as he noted, has been remembered more for her rape by (and the subsequent trial of) fellow artist Agostino Tassi. Transcripts of this trial exist, and perhaps this is her better-known legacy. I am not really interested in any of that. Susan Sontag notes in a 1995 interview with the *Paris Review* that an early stage in her development as a critic "was assuming that a principal task of art was to strengthen the adversarial consciousness." This adversarial consciousness, I assume, ferrets about in the liminal spaces between head and stem, like the bracts of an inflorescence newly in flower. Here, it seeks our attention.

She sits at her drawing desk. It's midday; she's getting anxious. The markers, watercolors, and chalks promised to her were supposed to arrive hours ago. As the light caves a little, slanting across the butcher paper laid out on the angled surface, she worries a vision from her fingers. She opens her legs and reaches inside. As she touches herself, the light goes warm and soft. The memory goes blank.

When Artemisia Gentileschi painted her self-portrait, she forgot to take into account how evening lusters her skin, how evening tenders a little sadness between her navel and the slopes of her ribcage, how memories come back in the crepuscular luminescence, her breasts milky and billowing, a firefly glow edging her body, casting a marginal corona. Instead she painted her self-portrait at dawn when, hardened by sleep, she could reach back through history and undo what had been done.

She stands up suddenly. The last few pages of the verdict sit on the sill in the northeast corner of the room. She walks over, picks up the papers, strikes a match, lights a tallow candle, meets page to flame, opens the window, and lets it all burn out over the yard. The citrus trees below bend with the fruit they bear, nodding and lazy in the warm wind. Her mind now open and easy, she returns to her seat and brings a colored pencil to her lips, chewing around the butt of it.

The killdeer runs through the grass, anxious to protect her young. She feigns a broken wing in order to distract potential predators. Dragging her outer pinion feathers across the dirt, she feints right, calls as distraction, runs down the cement path, away from the nest where four eggs rest, indistinguishable from surrounding stones under the highway overpass.

The nesting habits of killdeer seem to proliferate from human disturbance, adapted to the abundance of manmade ecosystems, an interruption at the edge between the natural and unnatural. They nest ever closer to humans, in a parking lot for public tennis courts, on the embankment of a railroad that runs through town, close to a stadium, in the gardens of a community college, on the shoulder of a gravel road, amid pebbles along the bank of a river running behind the grocery store. But always on the edge—the liminal space between nature and not-nature—and always on the ground.

When Judith sits on the rug of gold
and purple brocade in preparation
for the meal they are about to share,
Holofernes is seized with a violent
desire to strip off her jewels, her dress,
to pin her down; her maidservant
aloof at the edge of the room. He
drinks much more wine than this
supper calls for. Eventually, he slumps
over in stupor. A bellow escapes his
slackened lips. Judith gently rises,
brushes out her skirts with flattened
palms, steps over the girth of him.

When Artemisia paints Judith for
the first time, she has an experience
close to trance. She feels as though
she's been drugged, or hypnotized.
Painting has always come naturally
to her, but never has she been seized
like this.

In *The Dinner Party*, Artemisia sits in the second wing, between Elizabeth R (The Virgin Queen), and Dutch painter Anna Maria van Schurman, who began to read at the age of four and became proficient in fourteen languages over her lifetime, though she rarely spoke. Van Schurman was the first woman to attend University of Utrecht, where she was required, in all the lectures, to sit behind a curtain so that the men could not see her.

Judith also has a place at the table, in the first wing, next to Sappho, conjuring the rumors about Judith and her maidservant—that her servant was her Sapphic lover. Perhaps Artemisia saw it that way.

Judith's plate in *The Dinner Party* is full of drama: dark maroons and deep forests—a yellow center and red ridges, a shape something like the shadow of a football arcing over a late afternoon field. The "J" of Judith on the runner beneath her plate is pierced with a sword.

Artemisia's plate is much more sensual. An *x* with a wave factor, a fluidity of reason, as if arching the back to open the self up. A softening of rigid black slit among intensified pastel. Each wrinkle, roll of fat, shaded in a hue of green or orange or red. The conch, muscle chord, that lateral aperture, begging. The largest edible sea snail, high spire, siphonal canal. The "A" of Artemisia on the runner beneath her plate is pierced with the same sword.

Artemisia began painting at age seven as an observer of her father's workshop. Her natural skill was widely envied; she was falsely accused of having help. She began first by sketching on scraps of canvas left behind or disposed of by other members of the workshop: a loaf of crusty bread, a ceramic plate of green figs, a globe of Italian plums. No skulls, no compasses, no masks.

Her aunt called her "piping plover" when she was young because of the way she darted from room to room, the way her legs extended as she ran, seeming to reach beyond their means. A quiet rush to the edges of the property, but never beyond the bounds.

Artemisia's first catalogued painting is a rendition of Susannah and the Elders. In a biblically apocryphal story, the elders descend upon Susannah while she bathes unattended and make a deal: either she pleasures them or they will say she was meeting a man, fake some illicit tryst under a pistachio tree and turn her in for persecution and death. She chooses the latter, if this can be called a choice. Before her execution, a young man steps in and asks that the elders be questioned. Upon examination, they can't remember the tree—one claims an oak and the other a mastic, each very different in shadow and size.

Artemisia's rendition shows Susannah cowering from two lecherous old men. One whispers in the other's ear as he, in turn, makes a lewd gesture with his fingers in Susannah's face. Something silenced, someone willed to be silent. Artemisia would not be willed into silence. Susannah's hair cascades down her shoulder as she pushes the elders away.

Susannah's story is considered an addition to the book of Daniel. Only two books in the Bible are named after women: Esther and Ruth. Judith's story appears in a book named after her, a book excised from the canon, deemed—along with Esdras, Maccabees, Song of the Three Children—the Apocrypha. Judith and her deed have been resuscitated and kept alive by artists of different eras. Judith's book was excluded from the biblical canon because of an easily identifiable blending of fact and fiction. Judith's village, Bethulia, is not known to any historian—the name translates simply to "virginity."

In the '70s, the National Endowment for the Arts contributed a large amount of money to the creation of *The Dinner Party*. California State Representative Robert Dornan responded by publicly renouncing the NEA. During a debate in DC, he came off his seat a bit while yelling into the microphone: "*The Dinner Party* is not art, it's pornography!" Another representative echoed him, calling Chicago's work "weird sexual art," and another sponsored a measure seeking punishment through the withholding of other donated funds. A friend who interviewed Chicago during this time came to her accidental defense by claiming, of a precursory piece to the plates of the party, "Judy, I could look at these for the rest of my life and have no idea they're about cunts!"

The corpse plant generates its energy from the undergrowth of trees and the darkness of bacteria growing there, in the dense, damp soil. The plant lacks chlorophyll, hence its name. The killdeer's distraction tactics are occasionally picked up on by a tuned-in predator, and thus become instead a signal that a snack must be nearby, hidden in plain sight.

Roentgenograms of Artemisia's most famous painting, *Judith Slaying Holofernes*, show that she painstakingly arranged and rearranged the arms to get the angle just right, to make the beheading more violent than previously portrayed. Up close, the painting now shows bits of smudge, tiny erasure around the corners of Holofernes's mouth, as if a previous owner had tried to dampen the sheer horror on his face, the agony he must have felt at Judith's blade.

When the killdeer's defense mechanisms fail and the nest is found, she will rage against the attacker until her vocal cords burst and she is silenced, with her smashed eggs and unbroken wings.

Corpse plants are translucent, a ghostly white. They cluster in patches of dried leaves, forest floor detritus, each stem bearing one nodding bloom. Antler-like white leaves run up and down the slender stalk. They can easily be passed over or mistaken for another plant, and the succulent, crisp flesh easily snapped.

What the X-rays can't show whether Artemisia felt a sense of recompense or revenge through her rendering of Judith's story. Records show Agostino Tassi had plotted to destroy her family and steal her father's masterpieces. She may have felt something like love or obligation. Sontag writes in *Regarding the Pain of Others*: "the images say: This is what human beings are capable of doing—may volunteer to do, enthusiastically, self-righteously. Don't forget."

"Don't forget," Artemisia whispers to herself as she leans out the window, watching a few finches flit about the groves, singing playfully as they dash among the branches, pecking at the ripest fruits they pass. She sits back down and continues to sketch until well after nightfall, after the finches have tired and the tawny owls call to each other in search of the field mice who roam by moonlight.

Judith says, "Listen to me. I intend to do something." Then she does it. She puts on all of her jewelry, makes up her face, fills skeins with oils and wines, bakes cakes and fruit breads.

Holofernes, on the eleventh night of their unordained communing, again wine-sodden and quite drunk, passes out in his tent. Judith, according to the scripture, is alone. Her maidservant stands just outside the opening of the tent. Judith has told her to stay but, the King James Version implies, has not informed her of this night's intentions.

In Gentileschi's version of Judith, Judith's face resembles her own. Records suggest that Holofernes bears similarities to Agostino Tassi, her father's friend and Artemisia's tutor, though this cannot be confirmed as no known portraits of him remain. Unlike other renditions of Judith's story, here her maidservant takes an active role, holding Holofernes down as Judith makes the cut. This beheading is a collaborative effort. Artemisia repaints Judith's maidservant. This time she leans in a bit closer.

In 1991, nine-year-old Laura Arroyo answered a late evening knock at the door of her family home and disappeared. Her body was found early the next morning in a business park a few miles away from her home. A month later her image began appearing on an empty billboard standing between the site of her body and the site of her home, along Broadway, near the intersection with Highway 5. She appeared there nightly, her face flickering across the white vinyl tarps.

An interviewer, out of personal interest on behalf of his daughter, asks Judy Chicago, "So what would you say to a thirteen-year-old girl who wants to be an artist?"

Judy answers: "It's very important to learn her history as a woman, so if she encounters resistance anywhere along the line she has a context in which to understand it. Not understanding it is what defeats women." And thus, the singular becomes plural. The line bifurcates. One path becomes two. Two ways become many.

"Feminism," Chicago says, "is not monolithic."

Susan Sontag suggests that "real art has the capacity to make us nervous." We don't like to be made uncomfortable. We like to know what's coming. We read reviews, weather forecasts, horoscopes, stock market quotes. Sontag shrugs, urging that "what is important now is to recover our senses. We must learn to *see* more, to *hear* more, to *feel* more."

One edge coming unstitched, pain that persistently resurges. Some residents of the town religiously attended to the billboard, watching nightly or bi-nightly for Laura's face. A second face began to appear. This face was never identified.

Artemisia's favorite paints: robin's egg blue, fresh-blooded crimson, the fleshy brown-pink of an areola. Solid, faintly and forcefully feminine. Reminding her of him, of her lack of power under him, her exercised power over him. And maybe she did love him. In some way, our captors are not only our enemies, but the ones who understand us best, or teach us how best to understand ourselves.

Judith deigns to wine and dine and give herself to Holofernes all these nights knowing that in the end she will kill him. For the betterment of her people. This injustice to serve and eradicate a larger injustice. As she enters the bedchamber on the twelfth night she pauses as he murmurs in his drunken sleep. She knows what she must do but her hesitation might suggest some emotion other than courage. Perhaps something more tender arises within her before she crosses the threshold.

Corpse plants, also called Indian Pipe or ghost flowers, are scarce and often associated with beech trees. They feed off certain fungi that in turn ectocellularly retain photosynthetic nutrients from their host tree. The tree reaches up to the sun. A tree can host thousands of these hyphae in their root cortex before experiencing any significant damage or change. Their fruiting bodies bloom and bloat beneath the surface of the forest, in turn supplementing the corpse plant. If picked, a ghost flower will wither and blacken almost immediately, unable to support itself separate from this symbiosis.

The term *apocryphal* is used to describe a story or statement of doubtful authenticity.

At the trial Artemisia wasn't there necessarily to defend or to condemn Tassi. She had continued to sleep with him after he raped her. History suggests she was under the assumption that they would marry eventually and her name would again become clean. Each blank canvas lolling open before her, virginal and unadultrated. We don't know if she was in love with him. After the proceedings ended, she slipped a transcript of the case into her robes.

The Dinner Party was originally titled *25 Women Who Were Eaten Alive.* The name had to be changed when Chicago realized 25 wasn't representative enough, and the settings expanded to the current 39. Each wing of the triangular table holds a baker's dozen—the number present at the Last Supper.

Sir Francis Bacon describes revenge as a wild justice. It's also said that revenge is sweet, or best served cold, or that an eye for an eye will make the whole world blind. That revenge will make one inferior to thine enemy.

Shortly after the trial Artemisia is out on a walk to "gather colors," inspiration for her newest painting. She sees a cardinal hopping along the path in front of her, with just one wing. She picks him up with an easy hand, his yellow beak spackled with little black dots as though he had already ripened. She takes him home and nurses him, and he sings to her after she feeds him seeds and nuts. She names him Galileo, after the scientist who has comforted her, who writes her letters about the arrangements and geometries of the stars. She reads these out loud to the half-winged bird.

When the jugular is severed, the head comes off easy. His mouth twitches, an aftershock, in the same manner he fell asleep after orgasm. A human head can weigh up to twelve pounds. The eyes can continue to roll around to the back of the skull for up to twelve hours after decapitation.

Judith may have fallen in love with her maidservant, the way her muscles peaked inchoate as her arms stiffened to restrain Holofernes, how she grappled at his resistance. Maybe they both knew what they were getting themselves into. In some versions, the maidservant's name is Abra, meaning lesson, protector, mother of many.

When Artemisia's mother dies, her father comes to her in the yard to break the news, and Artemisia, already wary of what he will say, runs around to the cellar door and down the stairs, knocking over jars of canned peaches and pickled olives and rum punch. The glass shattering down the stairs behind her reminds her of rain against the window, her mother's nightingale voice as she hummed after night-fall. She aches to cry, yet can't.

Artemisia rushes into a little-used chamber and begins to tear at her hair. It comes out in clumps, her fingers wrapped in the strands. She punches her fists, now enveloped in hair, into the wall.

Her knuckles bleed into the hair, turning it a strawberry blonde, a champagne punch, a liquid rasp-berry ice. She continues this jab and hook until the wall is streaked with shades of red, a luminescent inquiry into the depths of her grief. She is twelve years old. She has no more female figures in her life. Soon she will begin to accept this, if not understand it.

Judith and her maidservant slip the head into a canvas sack. The sack used to hold a pistachio torte that has since been sliced and devoured by the now-slack mouth and lips, cold and blue from loss of blood. It is much heavier than either of them imagined. They lock eyes, briefly.

Revenge fantasies are often just fantasies. Some could easily be misread or misinterpreted as coping mechanisms. To be victimized is very different than to be victim. Sometimes, revenge is just a need to be righted, a yearning for a balm, a longing for some other emotion to course through the tensing veins of the body.

A teenage girl with a newly acquired driver's license makes her first solo trip down Highway 5 to visit her cousin in National City. She has painted her nails silver for the occasion—*diva glitz*, the shade's name, stamped out in tiny letters on the bottom of the polish bottle. She chews watermelon-flavored gum for the entire drive up. Her cousin is a few years older than her, and lives on her own, having moved down the road from her parents' complex after graduating high school and getting a job at a local beauty salon. Her apartment is cradled in fabric flowers: lilies, tulips, hyacinths, roses, chrysanthemums, sunflowers, daisies, pansies, birds of paradise, crocuses, hydrangeas, gladiolas, snapdragons. Each bouquet is a cluster of one species tucked into a simple glass jar or metal vase. Some of the flowers are intricate and ornate, and some are of the cheaper, dollar store variety. Some are decorated with tiny teardrops from the hot glue gun, as if they had just woken up to a soft dew, or were recovering from a light rain.

On the way home, nervous about driving in the dark, she cuts east to Broadway, a less busy road with more stoplights. She thinks about the conversation she had with her cousin over takeout pizza, the freedom of an empty road after nightfall, the homework she has yet to do. Then she notices an empty billboard; a flicker across it. The shape of a face. Maybe a shadow of a bird, she thinks, readjusting her eyes to the road, trying to shake the unmistakable image of a young girl with a high side ponytail, a hollow-eyed man looming behind her. She stole a tiny violet from her cousin's bathroom, and holds it on her thigh now, fingering the hard plastic ridge of the stem where the mold leaked a little, an imperfection in something immortal.

When she gets home, she rearranges her nightstand: a statue of the Virgin Guadalupe, an empty picture frame embellished with gaudy roses, a book she has yet to begin, an alarm clock in the shape of a duck, a pin of a skull

bedazzled with rhinestones, a note from a girlfriend at school about whom she has recently begun to dream. Her night lamp forces a shadow of her hand to descend upon each object before her fingers clutch it. She tucks the violet in the back of the book, shuts off the light and stands to look out the window.

The first critic of *The Dinner Party* took it upon himself to note that the piece "reiterates its theme with an insistence and vulgarity more appropriate, perhaps, to an advertising campaign than to a work of art." He also renamed it: "Crass and Solemn and Singleminded." He titled it "Very Bad Art." He dubbed it "Failed Art." He deemed it "Art So Mired in the Pieties of a Cause That It Quite Fails to Acquire Any Independent Artistic Life of Its Own."

In "Female Imagery," a coauthored edict of feminine art, Judy Chicago and Miriam Shapiro agree that "the woman artist, seeing herself as loathed, takes that very mark of her otherness and by asserting it as the hallmark of her iconography, establishes a vehicle by which to state the truth and beauty of her identity." Very bad art, failed art, art so mired in the pieties of a cause that the maker feels she must destroy herself by the end of it. As the sun sinks lower, a quiver of a self, eaten alive, darts across the idle moon.

Chicago and Shapiro persist: "It is with this differing self perception that the woman artist moves into the world and begins to define all aspects of experience through her own modes of perception which, at their very base, differ from the society's, inasmuch as her self definition is in direct conflict with the definition of woman held by the society at large." She perseveres, in the only way she knows how. At the dumb expense of public opinion, a familiar, archetypal swelling in her chest, a sibylline understanding of what must come next—slithering through her skull, scintillating her synapses.

In Artemisia's painting, the trajectory of blood follows an arc never before seen in high art. Holofernes's wounds spurt in accordance with the parabolic path of projectiles. It soaks the mattress beneath his head in rivulets of cardinal red.

The storm swell, if acknowledged early enough, may serve as an alert, and thus allow for the proper preparation. The storm swell can serve as a natural warning against a natural disaster.

When questioned about the legitimacy of art, Judy Chicago answers that making art can't be life, but rather that making art is the creation of a symbolic reality. Only symbolic reality—nothing else is art. She says in the same interview that Picasso disfigured and dehumanized the women in his paintings and de Kooning stabbed, rather than painted, his subjects.

The man who nicknamed Judy "Chicago" did so due to her thick windy-city accent. Her birth-given surname tied her to her Jewish heritage. Her father came from 23 generations of rabbis, thus fittingly he named his only daughter Judith, meaning first "jewess" and later "she will be praised." She says art came naturally to her and she knew her fate by the age of five.

City servicemen put up orange plastic parking cones around the nest. Four large, rubbery, burnt-looking things to protect the eggs from concertgoers, who may or may not storm under the overpass, leaving a trail of Butterfinger wrappers, cigarette butts, and Natural Light 16-ounce cans in their wake. And the killdeer sits upon her eggs.

By end of the dinner party, Artemisia has nothing left to say. Nothing left to articulate. She has let it all slop out through the brush. Her maidservant is nowhere to be seen. Sappho sits with her legs spread, sucking on her index and middle fingers as she eyes Artemisia with a saucer-like gaze. Susan Sontag writes: "To make peace is to forget. To reconcile, it is necessary that memory be faulty and limited… it is desirable that the account of specific injustices dissolve into a more general understanding that human beings everywhere do terrible things to one another." The maidservant, having fled the scene, lets her hair down as soon as her face is flooded with the moonlight of a Brooklyn night in late September, shadows capering about in the fountain. She undresses before the plunge. Upstairs, the lights begin to flicker.

Soon the eggs hatch. The cones stay. Shells disappearing, crushed into the gravel that both cradled and camouflaged them. The killdeer fledglings are agile, precocious, with legs almost as long as their bodies. They move quickly, like little insects, up over the small hummocks of newly planted grass. The mother calls to them when they skitter too far away, and they call back, rushing across the pavement to the shadows of the bridge above them. The single tiny dark rings on their bold white chests wink as they disappear behind the cement pylons. As they mature, the second breast band will begin to appear and darken. When this band grows into place, blinking beneath the first, they will be able to fly.

In order to prove the allegations against Tassi, court officials must first prove that Artemisia is no longer a virgin. To effectively communicate this to the swarming masses, they string her up on a summer afternoon, the harsh sun illuminating her shames, as well as the things she cannot name as shame. They cork her open with thumbscrews; she could not nerve to cry out.

In Gustav Klimt's painting of Judith, she looks like a showgirl, masked in gold leaf, her left nipple exposed to the light. She wears a sheer robe and ornate gold collar, decorated with precious stones. Her lips slightly, seductively parted. Her eyes narrowed, in ecstasy or defiance. In the bottom right-hand corner of the frame she palms the head of Holofernes, though from the painting it's not clear whether this is before or after the beheading. Judith's head thrust backward; her hair an afro haloing above her.

ARCH OF NEMESES

Alice Walker went out walking, calling "Zora, Zora, where are you?" and Hurston answered "Alice, Alice, I am here!" Legend has it that Zora Neale Hurston photographed a zombie. Orgasm flared up inside her. The milk will expire in three days. And later that night after the breeze has left town for some other distant place, after the tablecloths have wended their own wet ways around the clothesline and the bottles of wine have rolled to the roosts of the red-eyed geese—after all of that is done, it will be revealed.

*

High moon and a light breeze. You in pain and I not yet. This must have been the most beautiful night there was. Through the base of our skulls we can feel the deep roots of our humanness, skin bursting to the touch. This must be what it means to feel gratitude. Will we ever admit our intentions, what we can catalogue as ammunition. Force open the lips, then things get real. Nothing minimalist about these matrices. We cocoon deeper into ourselves. The lies we told about the lies we told. This is how stories work.

*

Nan Goldin's *The Ballad of Sexual Dependency* takes its title from a song

in Bertolt Brecht and Kurt Weill's *Threepenny Opera*, originally *Dreigroschenoper*—a phrase that denotes something small, trifling, disposable. When projected in sequence, Goldin's cycle of photographs, taken between the late 1970s and early 1980s, lasts almost 45 minutes. The slideshow is set to music iconic to the era: Petula Clark, The Velvet Underground, Dionne Warwick, Creatures. Each candid snapshot of this life is named for its subject, or their mood, or their location: "Amanda in the Mirror," "C.Z. and Max on the beach, Truro, Mass., 1976," "Cookie and Vittorio's wedding, New York City, 1986," "Twisting at my birthday party, New York City, 1980," "The Hug, New York City." Most of Goldin's subjects were dead within a decade of the snapping shutter. Friends and lovers and enemies, kissing and dancing, putting on makeup and taking it off, mirrors reflecting both beauty and flaws, crying and laughing, naked in bed, getting ready to go, getting ready to come, smoking cigars, smoking cigarettes, shooting up, at weddings, pissing or bathing, pregnant or injured, a blue towel around hair just after a shower, in a satin bra, leather top, red lips, blue wig, at dawn, in the back of a taxi after a night on the town, glinting in the fresh sun of a new day. The brevity of light.

*

Zora Neale Hurston's best-known novel, *Their Eyes Were Watching God*, begins with Janie Crawford returning to a town she has run off from. The women she had known in the past sit on their porches, still, and watch her walk home. Judgment clouds their heads in the coagulated summer air. Janie has come home after killing the man she loved. This wasn't an accident, but it certainly wasn't what she originally intended. She had little choice. It was self-defense.

It was mercy. As Hurston writes, "Now, women forget all those things they don't want to remember, and remember everything they don't want to forget. The dream is the truth. Then they act and do things accordingly."

*

Georgia O'Keeffe spent much of her life in love with Alfred Stieglitz. He represented her early work, she was in Texas, he paid her way out, they continued to correspond surreptitiously by letter. She writes to him, "I'm getting to like you so tremendously that it sometimes scares me…" and Stieglitz responds, "It's queer how fond I am of you, not at all as man and woman but something so different it's very wonderful and it hurts terribly." The letters continue until he finally divorces his wife and marries O'Keeffe in a small, private home with no decorum, no celebration. In the most famous photograph Stieglitz took of O'Keeffe she stares without emotion into the camera, her left palm sprawled across the butt of her right hand, the index and middle finger of which clasp her cheek, creating a small river of wrinkles under her eye. You can't tell what she's thinking. Her ring finger outlines perfectly the pout of her lip. Much later, they will split ways.

*

A young woman files a restraining order against her husband. One day she comes home to find that he has been there while she was out. He has

moved a small painting one-eighth of an inch to the left. He has been doing this once or twice a week for the past month. No one notices but her. Synnecrosis is a rarely used, archaic term of biological interaction. It indicates a caustic parasitic relationship: short-term, but so mutually destructive and inimical that it results in the death of both parties. This is infrequent, as it is not favored by evolution. Drawing to the close of the *death/ self* period of their collaboration, performance artists Marina Abramović and Ulay performed *Breathing In/Breathing Out*, which brought them both to their knees. Each of their mouths latched upon the mouth of the other, breathing in synchronicity until neither had any oxygen left. Full of the other's carbon dioxide, they passed out, collapsing into each other, soft as overripe fruit. It took seventeen minutes.

*

Right before Ana Mendieta died, Carl Andre was working on a series of boxes made of brushed metal. When shown in galleries, the boxes are lined up on a wall. This is not how he intended them to be. He intended them to be spaced equally apart, in a field of the bodies Mendieta burned in the ground. She sunk her form into mud, grass, flower, feather, flame, sand, cement. She titled these earth-body imprints *Silueta Works*, her human nature embedded in a more powerful nature. In one photograph from the series, the form of her body, arms raised out around the head, is embedded in snow and ice, the legs and torso splashed in red. In another, the form of her body is dug into soft sand, and filled with roses. Another: whittled into rich mud, filled after with water. Another: her body sunk into the river

bank, scattered with oak leaves, brown and brittle—in the chest cavity, a fist-sized rock, painted red. In another, the shape of her body is carved into a fallen tree, a fire blazing out of it. Andre and Mendieta were married for ten months before her death. In an interview with the *Guardian*, Mendieta's sister Raquelin says, "Her death has really nothing to do with her work."

*

We each have our own definition of what it means to be with another. Nan Goldin's 1984 self-portrait "Nan One Month After Being Battered" shows the pupil of her left eye awash in blood, her cheeks yellowing with an old bruise, her lips a gash of red lipstick. Goldin never names Brian as her abuser, but it's generally assumed he was responsible. The photograph as witness, the art as evidence. At the edge of the woods Alice Walker and Zora Neale Hurston found one another. Walker was forty years old. The dense bone of the skull, the soft inner bark of a tree, the rigid lines along which we define our limitations. And this is what we call a face. This is what we call a trunk. This is what he meant when he said that the god in us is released as violence.

*

Later that night, in the still of the dark, we dance barefoot under the glass bulbs baubling across the backyard, the grass violent and coarse against the tender soles of our feet. The next day you call and I tell you: you were

drunk and I was drunk and we were drunk. I was dancing, I was falling in love, I came inside to check on you and you were packing your suitcases. I thought it was a joke. It wasn't a joke, you assure me. You were falling out of love. I want to hurt like you, but I can't. I'm not strong enough. I can feel your pain. I can try. I can fail. You leave then, but you will come back. You are unable to stay away from your own devastations, and so am I. And so we all. And so it goes.

*

In a 1974 performance, "Untitled (Blood Sign #2 / Body Tracks)," Ana Mendieta wears a long-sleeved white shirt and chinos. She stands facing a white wall, her arms raised above her in a Y. She slowly draws her hands and forearms down the wall, leaving behind streaks of red. She falls to her knees, stands and walks away. In a 1972 piece, "Untitled (Death of a Chicken)," Mendieta stands naked against a white wall, holding the feet of a decapitated chicken near her face with both hands. The chicken flaps its wings as blood splatters Mendieta's flesh. Its wings slow, and the performance is over.

*

When Brian met Nan for the first time in the back of a Lower East Village club, he gave her a mixtape. The first song on the B-side is this

extravagant, melodramatic, pitching voice of Brazilian descent. The lyrics, a proclamation of you and I, until we die, waver around stylized intensities and variegating frequencies. She listens to it on her headphones over and over and over as she stares across the East River, develops film in her burnt orange darkroom, walks home just before sunrise. After the ribbon rips, she will be unable to find the song anywhere, as if it had never existed.

*

We cannot determine the parameters of other people's thoughts about us. Just because I destroyed you doesn't mean I ever had it in me to own you. You never belonged to me. At the margin of the forest Zora appears. The fruits heavy on the lowest branches will soon soften, resembling thick hot custard released from an aching udder. We had this, and then we had nothing. The milk will expire in two days. We still have hope for each other. A female luna moth lacks a mouth. She does not eat. She exists solely to mate, to lay eggs, to procreate and perpetuate her species. As an adult, she will live just one week. She will not fly until she has mated. She will only be seen by chance, at night, fluttering around the bare light bulb, spent—one last burst of brilliance.

*

The critics and cynics of Hurston's world thought she didn't pay due credit to the pulse of the moment. They found Janie's flush and fertile resistance

to the movement of her era satirical. Insufficient. Janie was easily misunderstood. True, Hurston didn't follow the script of Racial Uplift, but then, Janie didn't live in the Harlem Renaissance. Perhaps this is why Alice Walker felt the need to reframe Zora Neale Hurston as a feminist: "I became aware of my need of Zora Neale Hurston's work some time before I knew her work existed." Walker notes and celebrates the "extreme highs and lows of [Hurston's] life, her undaunted pursuit of adventure, passionate emotional and sexual experience, and her love of freedom." Hurston left Janie Crawford scaling another peak, belonging to her sexuality as much as it belonged to her. Janie was ready for a climax of her own. In Hurston's art and Janie's life, this was more important—the fallen pear mushy under the weight of wet dead leaves from last season. A promise, budding. A life of one's own: decisive and full.

*

During its larval stage, the caddisfly builds itself a home in a body of water or long-standing puddle. Some will remain there for their entire lifespan. The structure will be either a case or a net, both of which utilize silk spun from the oral orifice supplemented with whatever happens to be available: sticks, stones, claws, beach glass, seaweeds, shells, sand. Some caddisfly find themselves in richer habitats than others, with access to more materials. The entomology of interdependence. These caddisflies rely more on their exterior abundance and use less of their self-produced silks; their bodies get softer, slower, tumid.

*

In *Rhythm 2* Marina Abramović attempts to recreate unconsciousness. In the first act, she takes a pill that makes her catatonic and her body becomes unresponsive while her mind remains lucid. She remembers nothing. In the second act, she takes a pill meant to control uncontrollable functions of the mind; her body remains present. She remembers nothing. The performance lasts five hours. In *Rhythm 0* Abramović puts herself at the mercy of the public. She sits surrounded by objects: a feather, a rose, a knife, honey, olive oil, a gun, a single bullet. She invites her audience to use these objects as they see fit. At first, they do nothing, then a man slices her neck, drinks her blood. People cut off her clothes, carry her around like a doll. Someone grabs the gun, and the gallery shuts the performance down. Everyone flees, unable to face her after treating her like an object.

*

In an amensalistic relationship, one party circumstantially inhibits or destroys the other without benefit or gain to themselves. The affecting organism is often larger than the affected, and the damage may not even affect it. The unharmed may cause damage by the very fact of its existence in the realm of the harmed. For example, no plants can grow under a black walnut tree because of a substance the tree secretes from its roots. When the tree is mature enough, plants growing under it will begin to wither and die. Just by sharing territory it inflicts injury. This does not mean that the disadvan-

taged party is inherently weaker, but is simply more susceptible. Carl Andre was charged with Ana Mendieta's death. A neighbor heard a scream. "Surely they were drunk, they were drunk all the time," the doorman said to the police. This is the way they had learned to live. Carl was acquitted, all charges were dropped. He chose to be tried with no jury present. No one but the judge to weigh his words. No witnesses, no peers.

*

The butterfly's chrysalis is a shroud in shades of gold, showy and ostentatious. Like a cobweb in its growth and differentiation. The repetition of patterns we have adjusted to or learned to need. Our protection stands among us, like a shell, too thin to be opaque. The pericardium encapsulating our hearts. A film still in a frame of flame. The milk expires tomorrow. Opaque, transparent, spun of silk, solid or meshlike, of various colors and composed of multiple layers, a butterfly larva will attach her cocoon to small twigs, vegetation, or fecal pellets, hiding her transformation from predators. She'll spin to the underside of some perch—a leaf, a porch railing, the side mirror of a rusted-out truck, the faucet of a little-used garden hose, an abandoned backyard birdbath, a suspended branch, something buried in detritus, whatever makes itself available.

*

Even the last time I see you, I don't want to talk and you don't want to talk,

so we drink. We drink water, we drink tea, we drink wine, we drink Campari over ice, we take shots. We fall into the photo booth, we fall into one another, we fall into bed. We are dangerous. Unarmed.

*

Georgia O'Keeffe's plate is last in line. Judy Chicago completes the third wing of the *Dinner Party* with this extravagant piece: it rises inches off of the table, sloped in greens and pinks, a black hole in the center. O'Keeffe says, "the men like to put me down as one of the best women painters. I am, in fact, one of the best painters." Chicago made this plate herself, alone in her studio, running her hands along the curves of ceramic, late at night, a soft hum of rain at the window. Stieglitz writes O'Keeffe a letter: "I love you, Dearest One, if I am capable of love."

*

Both Chicago and O'Keeffe were chided and chastised for the seeming vulgarity of their work: O'Keeffe's flowers and Chicago's butterflies. Chicago admired O'Keeffe, but O'Keeffe did not feel the same way. It's said that O'Keeffe refused to work with Chicago and rejected her invitation to the party. "Too showy," she RSVPed. She did not want to be thought of as celebrating the female form. She did not want to be mistaken for something she was not. Chicago set her a place anyway. It's said that just before she

died, O'Keeffe took off her clothes and walked across the scorched sand into a stunning mess of New Mexican sun.

*

It's said that just after Ana Mendieta died, Carl Andre made a sculpture based upon a photograph of the back of her head. The way the fan lifted the hair from her neck, and how the ends of the hair, when nearing the light, resembled little phosphorescent maggots. The kind he found as a child in rodent carcasses near the compost pile. That boy in the park. Working with what we have because there is nothing else to do. Andre made the sculpture out of plastic, not a medium in which he typically worked. He left it in his studio and occasionally used it to test a power tool or the heat of a particular solder.

*

As humans we need the innate structures of our internal bodies—how the bones, even though hidden, are typically found in the same ratios; how the organs come alone or in pairs; how the vertebrae slowly step their way out of the spine to test the diaphanous tautness of our skin; how the brain begins to develop, rationally; how, for protection, our skulls begin to fuse tighter around these pulsing connections; how our bodies grow in hemispherical symmetry. This is how beauty works. This is how we learn to see

things independently of our dependence. What becomes fuel for combat, and what we have no power in resisting, harrumphing in the burgeoning light of a free and lucid dawn.

*

After Brian beat Goldin he tried to apologize. She said, "No, thank you," through the heavy wooden door and went back to bed, pulling the blankets up over her head and rolling toward the window. She was becoming familiar with this. Some choose to use the term battered. The streetlights through the blinds cast everything in a dirty orange glow. Eventually most people move. Eventually most people find a place to come to rest. Most people need someone else to inscribe their headstone. Most people don't choose their own inscription. Nan didn't even need to look through the peephole. She knew him by the way he knocked.

*

True love doesn't always have positive connotations. We can never expect salvation, but sometimes it finds us. The light comes glittering after. When Marina Abramović and Ulay split ways, they walked toward each other from opposite ends of the Great Wall of China. She from the east, and he from the west. They each walked for 90 days. When they met in the middle, they said goodbye—this signified the end of their collaboration

and the end of their relationship. Abramović cites this as part of her oeuvre. Ulay does not claim it.

*

It's said that when Ulay comes back to Abramović after so many years they can do nothing but stare at one another. They are both wearing red. Her arms slowly extend across the table. His meet hers, halfway. They clasp hands, desperately but without chaos. He gives his head a small shake, releases her and stands. Sitting there alone, she wipes her eyes, pushes back her hair, looks down at her lap. There is not enough in this world to fill us up. It won't keep us from trying.

*

The vivid and viscous breath of a thing that takes on a life of its own. Walker gave Hurston a big glossy stone; she paid someone else to engrave it. Hurston ends Janie's life when Janie, compelled and alit, invites her own soul to come out and play. The last time I went to your new city, we didn't see each other. And when they went singing out into the independent dark, Hurston notes "they mocked everything human in death."

*

The caterpillar sheds her old skin, under which is a tougher skin that will become the chrysalis. A private transformation in public, metamorphosis. Unfurling ecchymosis petals in the darks of the cheekbones, the delicately lined skin under the eyes. Chicago forms and reforms the ceramic setting for O'Keeffe, elevating each curl and curve, sharpening some edges, smoothing others. This plate is so much more elaborate than the rest: dizzyingly three-dimensional, a hole in the shape of a lily, a clitoral jack-in-the-pulpit hood pouring over the petals and stems glazed shades of pistachio, peppermint, lavender, bone. Not a skull. Not a flower. Not a butterfly.

*

The butterfly performs various tricks: polymorphism, mimicry, aposematism. The butterfly suggests something else in the shape of the dark: mammalian eyespots and owls and bird droppings. The moth learns to resemble more dangerous creatures, more poisonous breeds. It takes on a familiar form: a tiger swallowtail without yellow, a monarch without orange, a rusty-tipped page without the rusty tips. A coloration of warning, a swirl of the baleful, the tiny thrill of pattering wings. We begin to resemble each other more and more. We admit this to ourselves, but rarely to each other. In public, other people take notice. And even when we stand up and say our goodbyes, we know it's not forever. We need one another. I need you

to feel my pain and you need me to feel yours. My pain begins to resemble your pain and your pain begins to sound like mine.

*

Brian saw the photographs. He felt deeply embarrassed. Goldin had photographed them a year before in bed. In the photograph, he is sitting on the edge of the mattress smoking, looking out the window. The photograph is tinted the grainy colors of the desert. The bed is a plain metal frame. Brian holds his cigarette in the crotch of his index and middle fingers. Right at the butt of it. Goldin, wearing long black sleeves, stares at him, suspiciously. Some may choose the term incredulous. She will not title this a self-portrait. "It will not happen again," he says, knocking a little harder on the door.

*

The butterfly's pupa state of mind is preparatory, transitional—a protection engendering change. Today is the day the milk expires. Vibrant seafoam green of the monarch butterfly chrysalis, hanging from an old window screen secured to the top of a fish tank. This must be the first mark of gold leaf. The sonorous and smeary smell of sweat dried to the hair of an armpit, sphagnum moss ripe with swamp water, a blond brew in a tall glass, a skunky joint, slow-cooked pork belly, pickled daikon radish, ajax, fat eggs,

grapefruit rind getting sharp in the bin, flesh not yet on fire, but beginning to wax—a change, not unwelcome nor unwarranted.

<center>*</center>

In a parasitic relationship, the parasite is generally much smaller than its host. If amorality has a home in love, a drone note accentuating a change in the music. The low thrum of pheasant deep in the mossy forest, beating her lonely wings against a lowly trunk. The warbling of a winter wren just after a sunrise storm, the striped maple striated with gashes too white to forget. Here when we meet the body begins to dissolve. There we have to put each other on, then take each other off. When Ana Mendieta's feet lost their grip just before she fell from the windowsill there was an instantaneous sound. The keen of a hermit thrush. A bottle breaking.

<center>*</center>

Eventually Georgia O'Keeffe stops collecting. She returns all the rocks, bones, stones, and shells she used as subject models back to the earth. She scatters and disperses them among the weeds growing along the edge of a field yawing open to desert behind her studio. She saves only one object: a tiny skull, belonging to some small rodent, maybe a pet. Alfred sends her another letter telling her how much he needs her, how he can't be the same without her. He begs her to come back: "How I wanted to photograph

you — the hands — the mouth — & eyes — & the enveloped in black body — the touch of white — & the throat—" She opens the window and lets the hot air rush in. As her eyesight begins to go she will only be able to see the periphery.

THE LAST SUPPER

[aperitif]

Judy Chicago created *The Dinner Party* "specifically 'to end the ongoing cycle of omission in which women were written out of the historical record.'" For some, this ongoing cycle of omission begins at birth—we forget the woman, we forget the umbilical tube through which we fed, we forget a pink cloying of vaginal canal as we etched our way out, we forget the liberal slip through labia that brought us into this world, the petulant nipple at which we sucked.

For some, this ongoing cycle of omission begins at death—we add these women, postmortem, to our canon, we call these women the mothers of the histories we are making, we claim these stories for our own. Yet we fail to recall what made up their lives before bringing us into this world.

We eat alive the histories of these women. We swallow up the birth and digest the death. We facilitate and memorialize their motherhood, the offspring of their work. The leftovers are shuffled, sheepishly, to the kitchen, where the platters will be emptied in the pig trough, or tossed to chickens, begging and scratching and squawking for food.

Chicago's transubstantiation relegates the body and the blood of her chosen women to a dish, not of food, but the platter itself. These plates, then, connect the women to the feast itself, rather than the means by which the meal is served. Here the women are not reduced to their genitalia, but prompted to deliver the agendas of their own making.

Each of the three sides of *The Dinner Party* holds thirteen place settings. As the superstition goes, when thirteen people sit to a table, the first to rise is the first to die. When thirteen sit to dine, one will be dead within a year. When thirteen place cards rest on a table, we will never recall the name on each.

Dreaming of a plate symbolizes our hunger for life, our potential and promise for the future. But this dream is ominous; if the plate in our dream is empty, the threat is emotional void, a need for inclusion, a suggestion to rethink priorities, a nudging to address from where this hunger arose. Perturbed, wrapped in damp sheets and itchy blankets, we wake, gasping for the roots and riches of our unsatisfied appetites.

In some versions, Jesus—the first to rise and the first to die—stands at the end of the meal and grabs a loaf of bread. "This is my body," he says, "take of it and eat." He raises his glass: "This is my blood, take of it and drink." And his disciples follow suit, dipping bread into wine, chasing wine with bread. The crimson liquid tucks into the yeasty pockets and the bulk of the bread greedily absorbs it.

*

In Leonardo da Vinci's *The Last Supper*, the table holds bread and wine.

After the last renovations, more dishes appeared. Eels, oranges. Scholars note these foods probably came from personal preference rather than historical accuracy, in accordance with Leonardo's preserved shopping lists.

In some versions, there may have been pomegranates, whole fish, local vegetables. In some versions, they were said to have eaten sacrificial lamb in the Upper Room, but in 2007 Pope Benedict XVI announced otherwise.

In some versions, Jesus ate nothing before he went to the Mount of Olives. All thirteen wash their feet before they enter the room. In Leonardo's version, Jesus's feet have been lost to renovations. In some versions, as Jesus washes the feet of his disciples, he says to Peter: "Thou should do as I have done to thee." In Salvador Dalí's 1955 *The Sacrament of the Last Supper*, the Upper Room is a temple in the sky, overlooking ocean and cliffs, joined from the skylight by a ghostly torso abiding over them. The sun busts in, gold from all directions.

Jesus knows he will die. He also knows he will be betrayed. In some versions, finger bowls and salt cellars rest on the table. In Leonardo's painting, a spill of salt rests near Judas, the betrayer, the salt of the earth. This means he will be useless, tasteless, "trodden under the foot of men." Some claim Leonardo modeled Judas off a man housed in the jails of Milan.

[first course]

My father hunts our family property. Although I never hunted with him I always helped track the deer once hit—my father an archer, with his bow and arrow. My brother was often too scared but I loved puzzling out the splashes of blood on the dry leaves, shining the flashlight ahead to find the next spatter. When we finally found the deer, I'd beg my father to slit open its stomach as he gutted it. The animal enthralled me: its cut throat, the still warm heart. Something even deeper intrigued me about the deer's last meal—the half-digested leaves and twigs in its stomach, the acidic sack of bile, bitter berries, mealy and melting flora.

Fish, too—a photograph of me crouched atop a picnic table, tiny toes at the fringe of soggy newspaper, donning a wet, pink swimsuit sagging at the crotch, engrossed in the gutting process—a bounty of lake trout nerve-flopping over last week's headlines and their own shimmery scales unsheathed from the body. Snagging the fish with an earthworm or a cricket or a crayfish, then cutting open its stomach to reveal the same earthworm or cricket or crayfish intact. The very same bait, the fish in a state of digestion having eaten immediately before death. The very same bait, which could be used again to catch the next fish, somehow perpetuating this cycle of eating and death.

Somehow it made sense to see what these animals had consumed just prior to dying, as if this helped me reconcile eating the animal. To know what their food looked like in their stomach I could then understand that this might be how the animal would eventually appear in my stomach, and if I were to die immediately upon eating, I could be cut open, this animal let out.

The United States has devoted particular attention to what people on death row order as their last supper. Maybe this interest arose upon the reinstatement of the death penalty in 1976, after it had been declared unconstitutional in 1972. It could be said that we care more about the last meal than who these people are, who they love, what they love, how they think, what they experienced, what they created, the late desires they tossed up to an unknown god, what they missed, what they wanted, what they lacked and what they regretted, what they held in their very souls—their imprint upon this earth.

Maybe it could be said that we care more about this last meal than the fact that the death penalty is still legal under the federal government and in 32 states.

Maybe we care more about how we can adapt the ideology of capital punishment to a fun game for a dinner party than we do about the fact that the combined population of those incarcerated in the United States would rank as the country's fourth-largest city, just ahead of Houston.

*

In fall 2013's *Lapham's Quarterly*, Brent Cunningham breaks down this cultural obsession for us: "the state, after all, has to distinguish the violence of its punishment from the violence it is punishing, and by allowing a last

meal and a final statement, a level of dignity and compassion are extended to the condemned that he didn't show his victims." Is this, though, dignity? Is this compassion? We allow a final meal. We allow a jury. We allow the convicted to speak. We are allowed to play these games from our self-righteous position of having done our jobs. How can we be wrong?

In 2007, photographer Melanie Dunea edited a coffee-table book called *My Last Supper* in which famous contemporary chefs share whimsical desires of their own last meals. In the book they also fantasize about who would be in the kitchen while they were at the table, who might attend, where it would be located, what they would drink. Anthony Bourdain, in the introduction, addresses the incarcerated: "and yet, when we ask ourselves and each other the question, what—if strapped to a chair, facing a fatal surge of electricity—would we want as that last taste of life, we seem to crave reminders of simpler, harder times. A crust of bread and butter. A duck confited in a broken home. Poor-people food. The food of the impoverished but (only in the abstract) the relatively carefree… eating well is about submission. About letting go."

Marie Antoinette says, "Let them eat cake." As she approaches the guillotine she asks that the rest of the cake be wrapped up for later. As she steps on her executioner's foot she whispers, "I'm sorry." There exists a sick desire to imbue meaning in these last words and last meals. We populate these sites with meaning. We project meaning onto these plates.

*

Cunningham elaborates: "the final turn of the screw is that prisoners often don't get what they ask for. It is the request, and not what is ultimately served—let alone what's actually consumed, which is often little or nothing—that is released to the press and broadcast to the public."

The first woman to be executed by United States government was Mary Surrett, who was said to have taken part in the conspiracy to assassinate Abraham Lincoln. A majority of the military commission recommended that because of "her sex and her age" her sentence should be reduced. President Andrew Johnson indicted her instead with the motive for metaphor, claiming she "kept the nest that hatched the egg."

The night before she was to be hanged, Surrett began to bleed profusely. Her womb tightened and quickened. She was fed, as her last meal, "wine and medication" to alleviate her menstrual cramps. It is unknown whether she had personally requested this pairing. Her last words, spoken to a man standing guard, are noted as "please don't let me fall."

[fourth course]

Audre Lorde says in "The Master's Tools Will Never Dismantle the Master's House" that "those of us who stand outside the circle of this society's definition of acceptable women" must learn on our own how to survive. She stresses the learning. Lorde teaches us that survival can't be taught.

*

A week after Maya Angelou passed away, historian Jessica Harris wrote an elegy of the bond they built over a series of meals together. In the final months of Angelou's life, Harris dropped by her home during a business trip to Greensboro. She writes of this visit: "It was perfection. It was lunch. It was our last meal together." The perfection of the last meal. These meals signify, trigger, allow us to meditate. Harris writes that Angelou was brightly dressed, at work on a stack of crossword puzzles, drinking scotch, forever "imperious and imperial: the phenomenal woman at home." Angelou desired chicken salad for lunch. And so they ate.

Cooking as tradition, culture, memory, requiem. The plate becomes inextricable from our desire for connection, for love. The plate becomes a metonym for how we live our lives. The fuller the plate, the fuller the life.

*

My chef, April Bloomfield, taught me to realize my own impulse for survival. She taught me how to prepare every meal like it was my last and chided me when I cried. "You are ruining my reputation," she screams at me, red-faced and disappointed, just as lunch shift begins on a hot day mid-July. I cry as she throws soggy chips from the perforated hotel pan resting in the hot pass in my direction. "Eat it," she demands. I do. Crying, she says, is not what we write into history, especially her story.

What I learn from April is that a clean station is a clean mind; in order to work, we must have our shit together. What I learn from her is that we must make our own greatness; that we must elbow our way to the sauté station. What I learn from April is that greatness as a woman means to always hunger for more, to be strong, to fill your own plate. To depend only upon your own survival mechanisms. To annihilate your own expectations. To never succumb to fear. Perfection, perhaps. "Don't leave us hanging," these women cry, as their stomachs writhe and gnarl with emptiness.

The record of death row last meal requests is public in Texas. This database, available to anyone with internet access, notes not only the person, correctional serial number, crime for which incarcerated, and request for the final meal, but also whether that request was granted or denied. For example, Carlos Santana was executed in 1993 having been denied his last meal request of "Justice, Temperance, with a side of Mercy."

Texas no longer offers a choice after a man in 2011 ordered a meal consisting of approximately 29,000 calories, and refused to eat any of it. They instead serve whatever is being offered on the menu at the facility that day. It is said that accepting a last meal is a sign of forgiveness to the judge and executioner.

*

Journalist Hannah Goldfield puts it like this: "We're captivated by our most gruesome criminals, and so we want to know everything about them, down to what they most liked to eat. To be reminded, perhaps, of their utter ordinariness and humanity, which makes their unimaginably transgressive acts all the more thrilling." An article she wrote for the *New Yorker* recounts these ideas in the wake of a failed pop-up restaurant proposition called "Death Row Dinners." The premise was simple: for a prix fixe of around fifty dollars you could get "a chance to eat like it's your last meal on earth." Simple. The proposed menus of these infamous last meals are studded on

placards that hang around necks in old mugshots. Take your pick, they say.

The anonymous creators of "Death Row Dinners" claim they were "shocked" and "saddened" by the sudden and overwhelming negative response to their business plan. They posted a statement on their website that the pop-up intended to "explore the concept of last meals" rather than exploit and romanticize the imprisoned to whom those last meals first belonged. It was to be an immersive experience, where the diners would empty their pockets upon arriving, and be "charged, sentenced, searched and frisked" at one of London's "top security restaurants." It was over before it even began. Both the website and the Twitter account were soon deleted.

*

My family ate at backwoods pubs and Olive Gardens and Outback Steakhouses and the occasional local diner. Spaghetti was usually involved, or some form of fried fish—we had an affinity for frog legs. But then something would happen—somewhere between the ordering and the eating my panic would set in. In the wake of my childhood fetish for the last meals of animals about to be consumed, I manifested a phobia of restaurants. My anxieties were epic.

It would begin with some offhand or backhanded comment, with watching a particular person eat, with someone swallowing their mozzarella stick the wrong way, or when the wallet was pulled out, the inevitable tussle over a check, the slamming shut of a cash register. I was overtaken by a feeling.

This feeling is hard to describe from a distance. This severance of selfhood would slouch back in her chair. The enormity of my sadness would loom up from under the table, from the freezer burn in the failing lowboys, from the poor grout job between the tiles in the bathroom, from the lone hamburger rolled and rotting beneath the ice machine, the eyes of the busboy, the curve of the drainpipe in the dish sink, the hot steam of fog released from the Hobart industrial dishwasher, the heavy plastic of the curtain shielding the walk-in, the belly of the convection, and the cheap, starchy, heavily bleached fabric napkins, the grit caught in the holes of the nonslip mat between the line and the pass. And so I folded. I crumbled; I couldn't breathe, couldn't bear the weight.

In *Powers of Horror: An Essay on Abjection*, Julia Kristeva describes this feeling: "there looms within abjection, one of those violent, dark revolts of inside, ejected beyond the scope of the possible, the tolerable, the thinkable. It lies there, quite close, but it cannot be assimilated... But simultaneously, just the same, that impetus, that spasm, that leap is drawn toward an elsewhere as tempting as it is condemned." This is a country that eludes my knowledge of living. My family has convinced me that this is definitely not genetic.

All I can muster from here is that these episodes stem from eating and dying. This might have more to do with family than with food, more with mood than atmosphere, more with the internal than the external. This might have more to do with me than anyone else. I might be attempting to reason fear out, plan it a menu, force it to follow a recipe. Therein looms what Kristeva notes: "food loathing is perhaps the most elementary and most archaic form of abjection." And therein lies the movement by which

my brain abides, the abjection in which my childhood self threw her body onto the black and white hexagonal tiles of a restaurant toilet stall and heaved, sobbing, after watching some fat guy take a bite of his burger and dribble ketchup into his sparse, scratchy, five o'clock shadow.

And therein lurches forth an afterglow, the resonating image in the eyelid by which the sun seems imperceptibly small, imperceptibly bright, a burning circle the size of a constricted pupil.

*

Later, I took up a form of method acting in order to both succumb to the attraction of my abjection and overcome my fear of food. I got a job in a kitchen. I stopped eating and started cooking.

*

While in New York, I mainly subsist on snacks at work or sandwiches from the deli at my train stop: soft white bun, thinly sliced turkey breast, thick American cheese, shredded lettuce, creamy mayonnaise. My fridge remains empty.

The first Christmas Day that I cook for April Bloomfield, I call my mom from a pay phone on Broadway north of Union Square on my way to work

because my cell phone is broken. After my shift shucking, I smoke a spliff with a back waiter and take the subway home well after midnight, the only other person in the car is a man masturbating, and I'm too stoned to say anything, too stoned to move. When I get off the train, I buy a sandwich and an extra-large beer from the deli and arrive home to find my apartment unlocked—the door ajar.

*

Pre-shift, mid-shift, post-shift, we eat toast slathered in soft butter, flakes of salt. We sneak cheeses and smoked trout from the walk-in, dark chocolate from dry storage. Early mornings the prep guys bring tamales from street stands in the Bronx, which we eat while we set up our stations. After closing, we drink Genesee Cream Ale from a can and eat confetti rice, all the mise en place leftover from service mixed up in it. Late at night, we walk up the street to the 24-hour deli and buy forties of Pacifico and sit upstairs playing cards, smoking cigarettes, speaking our broken Spanish. Then we go to the bar. Snort cocaine off house keys in dark corners. Down so many pickle-backs: the whiskey hot, the juice sharp and sour. Then we stumble home. This is my family.

*

The next morning I'll buy a soggy bacon, egg, and cheese from a street

vendor on my way to work. I'll leave it untouched and still wrapped on the train after I watch a woman in floral cotton pants drink from a full gallon of milk before putting it back in the plastic grocery bag at her feet, then wipe her mouth with the sleeve of her sweater, pull her hood over her head, and lay down for a nap.

[sixth course]

The first time I saw someone have a heart attack was during the annual Fourth of July parade in downtown Victorian West Branch. He was standing in the garden of the Chinese restaurant and from then on throughout my childhood I would carve wide circles around that flowerbed, worried about what I might see there. Afraid of what I would find.

There's a lack of representation. A void that needs to be filled. An attempt to fill it. *The Dinner Party* probes how we perform and reperform our identities. How often we reduce one person to one thing, to make of them something we can box up after lunch. So therein also lives the human desire to overcome, to abide, to get over and move past and all of the other prepositional means by which we continue. We learn to hyperbolize. We take a slice of the bread and allow it to resemble the loaf. We pour a glass of wine and let it stand for the bottle. We let one piece of ourselves define us. We subject others to the same. We loathe to succumb.

*

A website called *Criminal Element*, focused on the last meals of death row inmates, states that "over half the women who have been executed over the past 35 years have requested no meal at all." The author then makes a joke, in poor taste, that perhaps some of these women "dreamed of going six feet under in a size six." This language perpetuates the idea that people in prison deserve to suffer, and furthers a gendered stereotype that reduces

gender equality in an already compromised space. The assumptions inherent in this language reinforce and complicate the ideology of incarceration, categorizing entire groups of people as dangerous and less than human.

In January 2016, after an execution in Alabama, a local newspaper polls its readership, asking, "Do you think the death penalty is an effective deterrent to crime?" Of the 242 who answered, 25 percent said no, 24 percent said yes, and 51 percent said "maybe if it was used more."

[seventh course]

In a photo essay for *Mother Jones*, Celia Shapiro arranges a dozen of the more outrageous last meals requested from death row on cafeteria trays. A dozen hotdogs in buns, slathered in mustard. Cheez Doodles and a Kit-Kat. A pint of ice cream, mint chocolate chip. Frosted Flakes. A peach, a banana, a salad, two ranch dressings. These meals only represent the request and not what was actually cooked, placed on the table, or consumed. Each photograph is titled with the person's name and date of execution. In her artist statement Shapiro says composing these photographs "became a profound meditation on violence and how the state metes out justice and retribution. The meal is life given to the body, the execution is life taken from the body... the body politic [gives] sustenance to the body condemned." And yet the garish colors against a black background suggest something cartoonish, something playful, something dangerously pejorative to both the body given and the body consumed. Plastic cutlery. A paper napkin. A single glass of water.

*

Julie Green has painted and fired over 500 plates with blue shadowy likenesses of last meals in protest of the death penalty. Some of the plates have words and dates, others have phrases or final statements, others still an eerie rendition of a KFC bucket or slice of pizza. A review of an exhibition of these plates supplies us with the idea that "even choosing not to choose has meaning." Green has been criticized for trying to capitalize off capital punishment, but she insists the series is strictly for protest and not for profit.

Her shading and vanishing point, a classic still life perspective in cobalt: a single apple, a honey bun, a bag of jolly ranchers, a jar of pickles. Fried eggs, pork chops, a pitcher of milk. Coca-Cola and ice cream and cigarettes and coffee and hamburgers and French fries. On some plates, the word "none." On another, the words "Justice, equality, world peace."

She says that she used to support the death penalty until she started researching last meals: "The meals were so personal, they humanized death row for me." As long as the death penalty continues, so will her artwork. For each last meal, consumed or not, she will paint a plate. When displayed, she prefers them to cover the wall, floor to ceiling. The enormity of it.

*

To celebrate the opening of chef Daniel Boulud's sixteenth restaurant, he asked 100 of his closest chef acquaintances to paint a plate in commemoration. April Bloomfield's is a portrait of the Michelin Marshmallow Man. He's dreaming of a star. The star is painted red. They all sit on the shelves in the dining area, the décor to mark his homecoming back to DC. These chefs practiced their hand at another form of art. One paints his plate with a crab, another two red hands reach out of a labyrinth of Keith Haring–style squiggles, another paints a cartoony likeness of herself, "to represent [Boulud's] great sense of humor." Anthony Bourdain's plate: Boulud in a crisp chef's hat and jacket, blood spattering the front. The plates used for service at the restaurant are plain—white, ceramic, sustainable.

[eighth course]

When asked what piece of modern art she would dispose of, artist Cornelia Parker chose *The Dinner Party*: "It's almost like the biggest piece of victim art you've ever seen. And it takes up so much space!" She went on: "I quite like the idea of trying to fit it in some tiny bin—not a very feminist gesture but I don't think the piece is either."

*

When Mia Fineman first visited *The Dinner Party*, in rotation at the Brooklyn Museum after its 1979 San Francisco premiere, she was a budding feminist, "starry-eyed" at age fourteen, aroused by art and the female experience. When she revisited it twenty-seven years later, *The Dinner Party* had just found a permanent home in Brooklyn. In 2007, Fineman was instead a budding curator, eventually becoming an associate curator at the Metropolitan Museum of Art. In an article for *Slate* magazine, she claims the installation's "earnestness is out of step with today's endlessly self-ironizing sensibility. And its pudendal imagery, once radical, looks silly and heavy-handed today." But, she concludes, "with her magnum opus enshrined in Brooklyn, ready to receive a new generation of budding feminists, Chicago can finally claim her own place at the table."

In *The Dinner Party*'s early life, another critic took issue with Chicago, saying that she didn't feel comfortable being reduced to her genitalia, didn't

like the idea that if you turn women on their heads they all look the same. "Put your hand in your underpants," instructs comedian Caitlin Moran in her memoir *How to Be a Woman*: "a. Do you have a vagina? and b. Do you want to be in charge of it? If you answered 'yes' to both, then congratulations! You're a feminist."

I must imagine Chicago had something different in mind when she chose pudendal imagery: not just to put the cunt on a plate but also, as she says, to "challenge the prevalence of phallic forms in our society, which are so common that no one even notices them." Even if Moran and Chicago both wish to reclaim the female sex organs, one with a hand and one with a plate, Chicago, in turn, calls Moran "ignorant" and provincial for writing off women's progress throughout history.

Chicago is quoted in a 1980 article in *People* magazine as saying, "I want to show how women's experience can be a metaphor for human experience... Most people are like women, not free."

And now Chicago wants to expand that notion of the human experience in a contemporary realm, for this budding generation of tech-savvy feminists. But a 2017 interview in *W* magazine notes that, "Chicago, who said that her feminism has 'gone beyond intersectional,' seemed aghast at the idea of shying from working with vulvas and vaginas in order to be more inclusive to trans women. 'There's a lot of variation about how people define what it means to be a woman—we know that, and we know that it's not binary,' she said. 'However, most of the women who are women have vaginas, okay?'"

*

In "The Joy of Creating"—the introductory essay to Chicago's monograph *The Dinner Party: From Creation to Preservation*—she writes, "my intention was to do a reinterpretation of *The Last Supper* from the point of view of those who have done the cooking throughout history; hence, a 'dinner party.'" But today, professional cooking in the public sphere, if not in the private, is still a boy's club. A *New Yorker* profile of April Bloomfield includes her insistence that "her choice of vocation was more a practicality than a political statement. 'I don't think of being a woman in an industry of men… I didn't walk into the kitchen and go, 'Ooh, I'm a girl!' I didn't get into my chosen profession. I wanted to be good at something.'" Initially, she had wanted to be a cop.

*

Leonardo's *The Last Supper* is one of the most revisited tableaus for both its sincerity and farce. In some versions, Jesus and his disciples are rendered as superheroes or Barbies or Legos or television characters or celebrities or cockroaches. In 1998, artist Vik Muniz composed a triptych of the scene made entirely of chocolate syrups.

*

Eve takes a bite from the apple. In some versions, this is her last meal. She eats herself into the cycle of omission. In other versions, she eats her way out.

[ninth course]

The best meal I've ever had was when I was nine. My father got a deer early in the morning; I had a soccer game that afternoon. Out the second-story bay window the world closed to a stop; the autumnal leaves galloping into momentary completion. My father came up to the house to get me, I was drinking green tea sweetened with honey. He asked if I wanted to help track the deer. I did. When we found it, he gutted it and cut out the heart for us to eat. Back at the house, we washed the heart in the silver sink, the blood running thick rivulets into the drain. When he sliced it, the same hole appeared in each ventricle, the arrow shot straight through. We dipped each piece in egg yolk and breadcrumb, silently. In the skillet, the heart swelled gently: the girth of it. We ate it hot, with buttered sourdough and two fried eggs a piece, parsley garnishing the plate.

Judas was the thirteenth person to arrive at the Last Supper. The thirteenth seat is imbued with betrayal. The number thirteen is unlucky. We don't put the thirteenth floor on elevators, we eliminate it from the table settings, we never choose the thirteenth row on an airline and we do strange things on the thirteenth of each month. Especially if it falls on a Friday. Full course dinners typically come in rounds of five or six or eight or ten or twelve or sixteen. The thirteenth president of the United States, Millard Fillmore, who took office after Taylor's unexpected death, eventually died from complications of a stroke. His last words, upon being fed some soup, were: "the nourishment is palatable."

*

There's this joke in *The Sopranos*: Jesus is up on the cross and rasps, "Hey, Peter, heeeyyyy, Peter! Come here." And so Peter walks closer, and Jesus says, with his dying breath: "Hey, Peter, I can see your house from here!" I guess that's the punchline: *I can see your house from here.* The trivial things we notice in death. That we often overlook the larger and looming things at stake; that on occasion a situation warrants seeing beyond our typical range.

The most recent woman to be executed in the United States formed an intimate group with her fellow incarcerated women. She found the power in them, and in herself. She helped them realize their beauty, who they could be, what they held, what they were capable of. The narratives they could choose for themselves, as opposed to the stories other people told them about them. She prevented women from ending their own lives. She helped them recognize what their lives were worth. She pursued a degree through Emory University while on death row, and received her diploma with full pardon from a papal ambassador. The state board disagreed with this clemency. Her last words: she cried, she prayed, she sang "Amazing Grace," she sent her blessings out to everyone—even those who would not accept her blessings.

*

In Susan Dorothea White's 1988 painting *The First Supper*, women from religions all over the world convene to eat, meet, celebrate.

*

Fergus Henderson prefaces his recipe for marinated calf heart: "This is a wonderfully simple, delicious dish," assuring us that "the heart is not, as you might imagine, tough as old boots due to all the work it does, but in fact firm and meaty but giving." Meaty and firm, in fact, but giving.

[twelfth course]

In the kitchen, we gently fry milt with brown butter and capers, splash it with lemon and parsley, slide it onto toast. We cut roe sacks out of whole fish, their glossy eyes staring up at our faces, the faces of the executioners. I learn how to cleanly separate the meat breast of a chicken from the protection of its rib cage.

During my first week of work, I find myself in an extra-large chef's jacket with half of a pig's head in my hands. I'm holding his brains in with one palm and a pink plastic disposable razor in the other. I've been told to shave him, so I do—all the bristly little wires of hair around his snout. Next, he'll become head cheese, and be served on a charcuterie board to guests dressed in black tie, coming from or heading to somewhere else.

Later that week, I'm struggling with knife skills and a sous chef stays late, her hand on mine, showing me how to julienne, how to chiffonade, how to batonnet, how to brunoinse, how to supreme. The subtlety of the wrist motion for each. Then, one evening, April comes to the kitchen to teach me how to cut an onion, how to wield the blade so my eyes don't fill with tears.

*

The last time I eat in at the restaurant my friend and I get oysters: Beausoleil, with their thin, flat shells, flesh like paper, spreading the ocean to the back of the throat; Kumamoto, with their tiny, deep cups, flesh supple and thick with cucumber taste; Blue Points delicate as spun glass and Hog

Island Sweetwaters, the coveted fruit of the Pacific. We dress them: a splash of lemon, a sprinkle of champagne vinegar. I imagine each oyster puckers a little, flinching.

The shucker opens up blood clams with quick hands and sets them before us, the shells garish and weary with seaweeds and lichens, a fluted dark brown, the inner shell pearly white. Inside, the flesh is purple as a mouth, folds and crevices swelling with crimson liquid that splashes out onto the ice. It's drowning in its own blood. I can't bring myself to taste it, metallic saliva searing up under my tongue. As it sits, the ice melts under the ridges of the shells, spreading a milky pink liquid along the edges of the oyster tray. I push it toward the edge of the table and turn my head.

*

Food writer M.F.K. Fisher asks us to consider how "an oyster leads a dreadful but exciting life." French author Marguerite Duras writes in her recipe for leek soup: "Inside the houses the smell spreads very fast, very strong, ordinary like poor food, like the work of women, the sleeping of animals, like the vomit of new born babies. You can want to do nothing and then decide instead to do this: make leek soup. Between the will to do something and the will to do nothing is a thin, unchanging line: suicide."

Cleopatra's last meal before she drank the venom of the asp was figs. After Anthony died, she could eat nothing else. The purple fruits so ripe they bruised to black. She was insatiable, tearing the figs open with her small fingers, desperately tonguing the space where the interior petals grow together,

her tongue thickening with desire as the juice dripped down her chin.

<p style="text-align:center">*</p>

In M.F.K. Fisher's "An Alphabet for Gourmets," the letter *s* stands for *sadness*: "And for the mysterious appetite that often surges in us when our hearts are about to break and our lives seem too bleakly empty." Fisher goes on to tell a story about a man who loved his wife very much, and then she died. The love of his life was gone, and he traveled the coast stopping to eat at four or five restaurants: bread, potatoes, steak, pie, and cognac in between. He reprimanded himself later, not understanding how he could gorge himself while she was so newly passed. He was so deeply embarrassed. Fisher concludes, "he would always feel, in spite of himself, that sadness should not be connected so directly with gastronomy."

Sometimes we live in order to eat. Sure, it's grotesque, but we are, by nature, a grotesque species in our humanness. And in the grotesque is the element of caricature. We caricature what we cannot define. We make obscene what we do not understand. We, the salt of the earth.

<p style="text-align:center">*</p>

Audre Lorde continues: "I urge each of us here to reach down into that deep place of knowledge inside herself and tough that terror and loathing of any difference that lives there. See whose face it wears."

*

In 2011, Melanie Dunea makes a sequel to her coffee-table book: *My Last Supper: The Next Course*, featuring fifty more chefs and their fantasies. Fergus Henderson would like sea urchin, Muscadet, goat cheese, dark butter chocolate ice cream. Marco Pierro White says, "I can't imagine fantasizing about my last supper. Food is irrelevant at that stage of life." Rachel Ray says: "I really wouldn't want to know what my last meal was, because I certainly wouldn't enjoy it."

Again, I'm rife with guilty indecision at the dollar hotdog man's cart just southeast of Central Park. Later that day, at work, I watch the manager fire a dishwasher for eating an untouched cold-poached lobster off a plate bussed from the dining room during mid-service rush to prove a point about botulism or trichinosis or noroviruses or hepatitis or some other magically terrifying word that isn't real until it is. So many things are magically terrifying until they aren't; so many things don't seem real until they are. The menu-priced $18 half-lobster, dressed in its own guts, emulsified with lemon, oil, salt, tarragon, is supposed to end up in the compost with another two dozen just like it. There are those who order but never eat. There are those who eat, but never order. There's a difference between thrill and decadence. Necessity and luxury. Or at least these are things I can tell myself. The gross justification of an empty plate.

When my best friend and I get together we eat and drink with abandon. I realize now that this constitutes both my definition of love and my definition of luxury. I realize now how lucky I am to have identified that definition.

*

At a 2014 literature festival, a prominent male chef made disparaging remarks about female chefs, where he acknowledges that sure, there are women in professional kitchens, but perhaps they are not suited for the

demands of the industry. Chef Dominique Crenn responded publicly by asking, "Can you turn to the women in your life and ask for honest feedback about how these comments offend and hurt women who strive to reach their potential and feed their passion?" Her restaurant, Atelier Crenn, describes itself as "a painting. An empty white canvas… Here, from this place, an artist can suggest emotion. A lasting moment from childhood… little drawers of heartbeats."

*

Eventually I leave the kitchen and move to Alabama. I start dating someone and we are looking for a place to have dinner. We try a restaurant in a strip mall but it's closed. The place next door is open and we walk in and sit down and we are the only people in the place, save an old man. It feels okay. It feels right. We ask our teenage server for water and she brings us plastic bottles of the stuff and then it does not feel right anymore. That other feeling descends. It's my childhood self crouched over her porcelain bowl. It's what Kristeva names "the repugnance, the retching that thrusts me to the side and turns me away from defilement, sewage, and muck. The shame of compromise, of being in the middle of treachery." I try to take deep breaths. I ask my boyfriend if we can leave. He pays the waitress for the bottles of water and her time. I am already out the door. I try to breathe and we drive across the street to another restaurant. We go in and order and he pays and we sit next to a pretty neon blue fountain in the courtyard and there's a family near us finishing their meal, but the feeling won't quit me. All I can muster from here are all the worst sadnesses in

the world. All I can witness is myself, eating my last meal, choking down what I otherwise couldn't get out. I stand up from the table when our food is delivered, walk to the parking lot, and throw myself in the car. I open up all the little drawers of heartbeats from my childhood. And in this moment in the backseat of my boyfriend's car in the parking lot of the Purple Onion in a strip mall in Birmingham, I realize the delicacy of love's palate and the tenderness of the heart's work. It's hard work, and I don't yet know how to do it.

French performance artist Sophie Calle spends a few weeks living in the manner a man expects her to live. He has already written it, and so she plays along. In his novel *Leviathan*, author Paul Auster bases a character on Calle. The character, Maria, is very similar to Calle, but also very different. Calle catalogues her experience as Maria in a monograph called *Double Game*. Maria follows a chromatic diet. Each day Calle plates the food on a dish of the prescribed color, and the flatware matches; so does the glass.

On Monday, Sophie Calle sits down to a dinner of orange: puree of carrots, boiled prawns, cantaloupe. Paul Auster never mentions drinks, so Sophie allows herself orange juice.

On Tuesday, Sophie Calle sits down to red dinner: tomatoes, steak tartare, pomegranates. She adds roasted peppers and drinks red wine.

On Wednesday, Sophie Calle sits down to a dinner of white: flounder, potatoes, cheese. She adds rice and drinks milk.

On Thursday, Sophie Calle sits down to dinner of green: cucumber, broccoli, spinach. She decides to add: basil pasta, green grapes, kiwi fruit. She drinks a mint cordial.

Friday, Sophie Calle sits down; her dinner's all yellow. No color is prescribed to Maria for this day, as if she were not to eat, so Sophie picks her own color and imposes this menu: Afghan omelette, potato salad, a "Young Girl's Dream" (a banana with two appropriately placed scoops of

mango ice cream). She drinks Pschitt! fizzy lemon drink.

No food is given to Maria on Saturday, either, as if women don't eat on the weekends. Calle chooses pink: ham, taramasalata, strawberry ice cream, rosé.

On Sunday, with no food by the book, Sophie decides to set all the week's dinners on a black tablecloth, and invites her friends to join. She says of the experience, "personally, I preferred not to eat; novels are all very well but not necessarily so very delectable if you live them to the letter."

SALT OF THE EARTH

I'm jogging in my neighborhood when I pass a house that has been transformed into a live action game center called "BREAKOUT." Their sign asks: "Are you up for the challenge?" In America, we love to pass our free time like this: we pay someone to lock us and our dear friends in a room, then try to "break out" of that room in a certain amount of time. This is what we do as a family on a Saturday afternoon. The house is located less than five city blocks from the local jail. One of the "rooms" you can choose, if you choose to participate in this game, is "Detention" and another an expedition into the "African Wilds" gone wrong. The website tells potential customers that all it takes to BREAKOUT is "luck, skill, willpower, divine intervention."

*

Michelle Olley stands up a bit straighter. She's backstage, completely naked. Her breasts hang low and heavy. Her body is powdered, primped, and prodded. She's nervous as hell. Two make-up artists around her age glue moths to her flesh: three above her left breast. They tell her, don't be embarrassed about being naked, we're both mothers too. Michelle is not a mother. The glue puckers her skin as it did in grade school: Elmer's covering her fingers instead of construction paper, red and purple and orange dyes rubbing off and mixing in, her flesh a veritable rainbow. Two smaller moths on her left shin, wings closed, and a luna moth spread open in between them. Her body feels ready. The luna moth falls off, is re-stuck. Two

entomologists flutter about, keeping a close eye on their stock. Michelle's been keeping a diary in the days leading up to this one. She writes, "in my little cocoon head, covered in perilously glued-on, highly breakable insects, I feel pretty placid. Have done since the mask went on." The mask is a silver number, bat-ear horned. Her body is primed, powered. Her belly as slick as a fishlip split. Her body becomes more her own than it has ever been.

*

Emma Donoghue's 2010 novel *Room* details a young woman, kidnapped and held captive in a converted garden shed by a middle-aged man called Old Nick, who rapes her almost daily. He gets her pregnant, makes her get rid of the baby; gets her pregnant again; she insists on keeping it. So now her son lives with her too; they inhabit a tiny room, ten feet by ten feet, and this is all her son knows of the world. He turns five at the beginning of the novel. The novel won a Man Booker prize and was made into a film that was nominated for four Oscars, and won one.

In 2011, *New Yorker* staff conduct an interview with Donoghue while she's at home in Ontario eating a chicken pot pie. At one point, she types: "Although my conscience is clear, in that I was not exploiting any real individual's story in writing *Room*, of course I was aware that my novel, by commenting on such situations, would run the risk of falling into those traps of voyeurism, sensationalism and sentimentality… when I was researching confinement cases I became… fascinated by my sources… Especially that unnerving mixture of the saccharine and the judgmental; it seems that

we set up these Suffering Girls only to bludgeon them off their pedestals."

Meanwhile, a middle-aged man named Ariel Castro is holding three young women captive in his two-story house in Cleveland, Ohio. He kidnapped them at different times: Michelle Knight in 2002, the day before she was supposed to appear in court for a child custody case; Amanda Berry in 2003, walking home from her high school job at Burger King; Gina DeJesus in 2004 from a payphone outside her middle school. He keeps them in separate rooms, sometimes; sometimes, the same room. He feeds them one meal a day, sometimes; sometimes, two. Sometimes he doesn't feed them at all. He impregnates them and sometimes forces the end of their pregnancies: sometimes with bricks, sometimes with fists. The girls won't be found for two more years.

*

Alexander McQueen has chosen Michelle Olley to model for him for fashion week: his spring 2001 collection, VOSS. At the end of the show there's a countdown, lights out, the runway models leave and then the glass walls fall, shattering. Olley's stuck inside a box, inside another box; the whole stage a cage. *Vogue* describes it as "a mirrored cube, which, when lit from inside, revealed itself to be a mental-hospital holding cell." Kate Moss, Stella Tenant, Karen Elson playact "demented girls"—running their hands along the glass, nude makeup, eyes sleepy and distant, tearing at their dresses. They all wear flesh-colored nylons keeping their hair tight to their heads. The outer walls are one-way mirrors: the audience can see in, but the models can't see out.

On the morning of May 6, 2013, the three kidnapped women in Cleveland are rescued. I drive a friend to her MRI scan. We get a beer after and she talks about how the machine, while she was stuck inside it, made this whirring hum that sounded like a delirious cartoon character: *happyhappy-happyhappyhappy*. We grab a barbeque lunch, the television tuned to a news station—footage of the release. None of the women want to be interviewed. Day-buzzed, I tell my friend I want one of them to write a memoir. She shoots me a look of disgust over her fried catfish, sets down her plastic fork. "Really?" she asks, "Why?" I don't know what to say. What makes me want to read about the horror they experienced; why this fascination taking root in my gut? I respond with some bullshit about empowerment and writing through experience and though this is true, I don't think it's the reason I said it.

That fall Michelle Knight does publish a memoir, called *Finding Me*. Her story is one of brutal triumph. She was alone in the house for almost a year before the next girl was kidnapped. She was kept alone in the top story of the house. She was rarely allowed to interact with the others. Castro bought her a puppy and then, a few months later, wrung its neck and made her watch. No one had really looked for her. According to her memoir, it seems like Knight got the worst of it. Berry and DeJesus don't talk to her anymore but in interviews they say they wish her the best.

In 2012, wandering around *Savage Beauty*, the Alexander McQueen retrospective at the Metropolitan Museum of Art, I stumble upon the projection of Michelle Olley attached to her breathing tube through that bat mask, butterflies glued to her naked body. It reminds me of my grandmother, pushing her oxygen tank through the mall near Christmas, just a

few months before she died, the tinny sounds of carols echoing wildly, the grotesque face of Santa Claus leering from shop windows as I ran from one store to the next, desperate for things to own, to call mine. It reminds me of my own mask of virility, petals of shame crawling up my face.

There are no butterflies in Joel-Peter Witkin's photograph *Sanitarium*, McQueen's inspiration for the show. Just an obese woman attached to a tube, the tube attached to the mouth and genitals of a taxidermied monkey. The photograph, according to Witkin, was inspired by an article about anthrax. He says his photographs reflect the "unavoidable connections" of things.

*

In America, so many of us love entertainment that fetishizes a loss of the very freedoms upon which we pride ourselves. We love movies like *Saw* and *Hostel* and *The Purge*. There's something entertaining to us about watching someone stuck in a room, trying to find their way out, battling for their lives. There's a market for paying to be voluntarily stuck in a room, in order to find a way out.

In 2015, a Lifetime movie is made about the Cleveland Three, based on Michelle Knight's memoir. Her character is the star, played by Taryn Manning, who hit celebrity status for her portrayal of villain-victim Pennsatucky on the Netflix show *Orange Is the New Black*, which takes place in a women's prison.

*

The main character of Emma Donoghue's *Room* eventually escapes and tries to kill herself.

*

There's a prison in New Mexico called Old Main, now vacant, that served as a location for filming *All the Pretty Horses* and *Zero Dark Thirty*. Before that, in 1980, it had been the site of a 36-hour siege in which 33 people died. This remains one of the most violent uprisings at one of the most corrupt institutions in United States history. Old Main closed in 1998, and now, for $15, you can take a two-hour tour. When you get there, you are assigned an institutional number and have your photograph taken for "booking." Then, the guide walks you and your group step-by-step through the riot. A journalist for *Vice* magazine took the tour, and writes that it "allows people to experience a permanent nightmare in the American collective conscious: prison." The nightmare here being not the prison itself, but the people inside.

In another country, people are going to prison to eat. In October 2015, a restaurant opened in Milan called InGalera, Italian slang for "In Prison"— an apt name since the restaurant is literally in a prison. InGalera presents a form of rehabilitation—the incarcerated men work in the kitchen, cooking, as well as on the floor, serving the guests. The menu is made up of tradi-

tional and experimental Italian dishes. It's high-end, aimed at an audience who can afford to dress fancy, dine out. The owner is quoted in an article in the *New York Times*: "Our first worry was: Who would come? ... But many people are coming." The author of the article surmises that "curiosity about a forbidden and feared world has turned a night at InGalera into a daring adventure, with a fine meal as a bonus."

*

In her 1899 story "The Yellow Wallpaper," Charlotte Perkins Gilman's narrator is confined to a nursery to convalesce and begins to see women stuck behind the wallpaper, begging for a way out. She tears the wallpaper down, tries to help, but instead is forever doomed to crawl around that same room, digging a rut into the wall with her shoulder.

*

The Escape from Angola triathlon was to include a one-mile swim, a forty-four-mile bike ride, and a ten-mile run across the 18,000 acres of land upon which a prison sits. Escape from Angola was to be hosted on the property of the Louisiana State Penitentiary, the largest maximum-security prison in the United States. The website offers that "after several logistic meetings and facility tours, Escape from Angola was born." The medals for finishers were to be replica keys to the prison. The top winners in each category by

age and gender were to win retired keys from the prison. For those traveling from far away, there was an overnight package available. Racers would sleep in former cell blocks of the unit that was, until a decade ago, death row.

After the race was widely criticized, the Baton Rouge *Advocate* published an article announcing its cancellation. Over 350 people had already signed up, paying the $150 entry fee. The organizer made it clear that "athletes would have been safe from offenders and otherwise face the same risks posed by any Louisiana terrain." The website has since been 404ed. There is, though, an Escape from Alcatraz triathlon that's been going on for the last four decades. It begins on Alcatraz Island, home of the famous prison, with a one-and-a-half-mile swim to the mainland, and ends under the Golden Gate Bridge. Their website asks if you are "Ready to Make your ESCAPE?"

Angola's property is also home to a nine-hole golf course, "offering a spectacular view of Louisiana's only maximum security prison." Among those not allowed to play this course: those formerly incarcerated, those without proper ID, those without verified background checks, anyone listed on a current or former facility visitation list.

The incarcerated men assigned to the course tend the green and cook in the pro shop restaurant. Angola is also the home of the Prison Rodeo, a twice-annual event attended by thousands of spectators. Dr. Mary Gould, who studies prison tourism through a lens of performance studies, concludes that the Rodeo "reinforces the power inherent in the position of 'free' non-incarcerated citizens." Playing golf or competing in a triathlon on prison property, as someone not incarcerated who chooses to leisure their time away as such, makes the free feel freer. Gould also notes that

these forms of tourism put prison "on display for visitors in a way that does not accurately represent the past or present reality of the daily experience of incarceration." A woman I met at an art show told me I should go to the Prison Rodeo sometime because "it's a real riot." She had taken her children, ages seven and nine. "They had so much fun," she said.

*

Joel-Peter Witkin eventually began to work in Mexico because he was no longer allowed to photograph as he desired in the United States: to work with corpses and dwarves and transsexuals and intersex persons and the physically deformed. The corpses were the thing the United States kicked him out for, saying that his images were exploitative and upsetting and shocking to public opinion. I guess the thing I really want to know is who defines public opinion.

*

The second wing of Judy Chicago's *The Dinner Party* boasts a place setting for Eleanor of Aquitaine. Eleanor was one of the most powerful women of the Middle Ages. She became queen of France and organized women to attend the sick and aid in fighting during the Crusades. After her marriage to Louis VII ended, she married Henry II of England, who imprisoned her and laid claim to her property. She was kept sequestered for sixteen

years, released for holidays like Christmas and then locked up again. She was thought to be kept primarily in Haughmond Abbey, a triangular castle.

Her place setting in *The Dinner Party* is based on *The Unicorn in Captivity*, which is one of the tapestries on display at The Cloisters museum in Manhattan. The tapestry depicts a unicorn chained to a tree, lying down in the middle of a small circular fence surrounded by a field of flowers. Eleanor's plate sits surrounded by a garden full of blossoms. Judy Chicago says that this symbolism "seemed to provide an appropriate visual metaphor for Eleanor's own imprisonment."

*

The Dinner Party itself is a container, housing these histories. Confined to a plate. Stuck in the museum. A living history suggests lateral movement. Our histories immortal, we are trapped by the past. Here, static, we stand. Containment suggests protection, a fitting, or match. Confinement suggests something else: restriction, inaccessibility. You may be both contained and confined by your position. Karin Woodley writes in "The Inner Sanctum," her review of *The Dinner Party*, that "an exhibition which attempts to show the contribution of women to Western civilization using a triangle banqueting table strewn with altar cloths, 39 place settings representing 999 women grouped together according to common experience, achievement, historic period or place of origin within the context of a sacramental celebration, in my opinion is doomed to failure." There's no way we can fit all of this into such a small space.

*

Some people put rice in their saltshaker to keep the moisture out. Some use crackers, or nothing at all, then it clumps. Lot's wife, turning back, in perpetuity. And the particular woman-ness of this: a pillar of salt, rendered voiceless, motionless. Rubbing salt in the wound. Salt is a cubic compound made up of two chemicals, in equal proportions, and is easily dissolved. It takes form in the ocean; it's been used to build roads, statues, houses.

Salt, symbolic of Earth, is said to cleanse areas of bad energies. During many rituals, the altar will harbor a dish of salt and a dish of water. Saltwater helps clean passageways. In the 1970s pregnant women who no longer wanted to be pregnant went to New York, where they would have an installation abortion. In this procedure, amniotic fluids are replaced by a saline solution that poisons the baby and slowly corrodes the outer layer of skin. Labor is induced. In 2015, the captains of a University of Alabama fraternity made their pledges stand in buckets of ice and salt for hours. This resulted in third-degree burns on the pledges' feet. The captains were arrested, and released on bail.

*

The synopsis of *Cleveland Abduction*, starring Taryn Manning as Michelle Knight, on Lifetime's website reads: "When Berry became pregnant with Castro's child, it was Knight who delivered her baby, even performing

CPR on the infant girl under the threat of Castro while he told her, 'If the baby dies, you die.' Despite enduring more than a decade of brutality, Michelle's spirit would not be broken, and her unshakable faith in the face of a seemingly hopeless situation was a testament to the human spirit. On May 6, 2013, Michelle was rescued from the home that was her prison for nearly 11 years, and finally given the chance to reclaim her life."

*

Alice feels stuck in the house, so she goes to read by the river. She sees a rabbit, and follows it down a hole. The rabbit goes to Wonderland, and then Alice gets stuck in Wonderland. In Wonderland, Alice finds the rabbit at his house, and goes inside. In the house, she eats a cookie frosted with the phrase "Try Me." She gets stuck in the house. She swells so large her feet come out the windows, her head in the attic. We fit ourselves into boxes. We force each other into roles. We peg the strangers walking down the street as *this kind* or *that kind*. No delicacy about it. It's rhythmic, routine. Like checking the mail, the time, the stove, the shoes for dog shit. The door for locked.

*

There's an episode of *Love + Radio*'s podcast called "The Living Room" in which a woman is obsessed with how her neighbors across the courtyard from her third-story window in Manhattan never close their curtains. She

thinks it's absurd. She doesn't want to move her couch. She thinks it's obnoxious, she doesn't want to close *her* curtains. She resents and envies them, and then she begins to fall in love with them. They're having sex all the time, they're always naked, and then the woman across the courtyard is alone, for so long, crying, before the man comes home. It's clear he's sick. The woman watching begins to leave work early, to nestle into the couch and wait for what happens next, looking out at their window. It's even better than television, this real life. And then a mother shows up. And then it's clear that she's watching a death. She can't stop. Her bottle of wine, her nightly routine. She feels an intimacy with the people in the room across from hers—an entire life plays out, there before her eyes, in real time.

*

Jack and Ma have one window in *Room*, a skylight of thick, quilted glass. Emma Donoghue says when researching the book, she felt "creepy" looking up what kind of shockproof security glass a man like Old Nick might buy to let a bit of filtered sun in, but not let anything else out. Donoghue says, "it made me realise that the author is always the Old Nick of her book: locking her characters in, deciding what resources to allot them, what's going to happen."

At one point, a dry leaf falls on the skylight. Jack freaks out. All the leaves on TV are green, he doesn't believe it's real. He doesn't understand rotting, nature, life cycles. They have a plant in *Room*, but that's all he knows of flora. He knows no world outside this room, outside what he's learned from TV, that tiny box within that tiny room.

Joel-Peter Witkin includes requests for models at the end of his monograph; one reads: "I need physical marvels—a person, thing or act so extraordinary as to inspire wonder: someone with wings, horns, tails, fins, claws, reversed feet, head, hands... Anyone without a face... Anyone bearing the wounds of Christ. Anyone claiming to be God."

Michelle Olley lies still, propped up on a divan. The live butterflies pumped into the vitrine hover around her. Her breasts droop along her round stomach. Eerie sounds: the fluttering of wings, the deep gasp of the oxygen. One magazine said that voss "was about trying to trap something that wasn't conventionally beautiful to show that beauty comes from within." As if beauty, like a butterfly, is a thing we can trap. When the walls fall, the butterflies fly in all directions.

*

For one month at the beginning of 1972, Judy Chicago and Miriam Shapiro, then both professors of feminist art at the CalArts Institute, decided to move their female students. For one month, they all lived and worked in an installation and performance space called *Womanhouse*. *Womanhouse* was a response to the lack of studio space given to the program by the academy. They decided to literalize the ideological conflation of women and houses by creating a domestic space in which their art could exist. They found a seventeen-room dilapidated mansion that would serve as a location for their

"dreams and fantasies." They worked for three months, eight hours a day, to renovate it. The students started to feel bitter toward Chicago and Shapiro, viewing them as "monsters" and resenting their "impossible" demands. One artist says: "I left the Program after one year, because of my disagreements, and because I wanted to experience the school outside the confines of the Program. I have avoided group feminism since then."

For the opening day, only women were allowed to view the exhibition. The rooms of *Womanhouse* were full of art: in the kitchen, plates of food sit under fluorescent lights, an assembly line. In a closet, a mannequin's body is vivisected with drawers and shelves, upon which sit folded sheets and towels and washcloths; in a bathroom, all white, sits a trashcan in the corner, overflowing with used tampons. "The Dollhouse Room," a collaboration between Shapiro and a student, represents the tension between "supposed safety and comfort in the home" and "terrors existing within its walls." *Womanhouse* was critiqued, challenged, and praised for taking "private and collective female experiences" and putting them on display for the public. One participant responded to the project 25 years later: "Put 30 women together and see what happens. A nightmare." In a 1982 interview, Dinah Dossor remarked to Judy Chicago midway through their conversation: "One thing I found odd about *The Womanhouse Project* was that the women who were all working in the same building said they felt isolated." Chicago responded: "Yes. Isn't that peculiar?"

*

The final entry in Michelle Olley's voss diary reads: "I want people to know what I just went through wasn't a breeze and I did it for art. Yes, art.

Because I believe it's worth going through that much palaver if it creates a strong image that conveys an important idea. And I believe that the idea that we are trapped by our 'civilised,' socially approved identities is massively important. It causes women so much suffering. Fear of ageing, fear of not being thin enough. Fear of not having the right clothes. Fear of our animal natures that we carry in our DNA—fish, bird, lizard, insect, mammal."

*

Saint Bridget's place setting in Judy Chicago's *The Dinner Party* is a column of fire. The fire vulval, green outshoots rimmed with blue—an igneous labellum. Bridget, the patron of midwives and milkmaids, dairymaids, infants, children born into abusive unions. When of marrying age, Saint Bridget met a man who taunted her, saying that because of the beautiful eye in her head she would become betrothed to a man whether she liked it or not. In response, Bridget plunged a finger into her eye and handed it to him, saying, here is that beautiful eye for you, no one will ask for a blind girl's hand. She warned him that soon his eyes would bust like two grapes inside his head—as he laughed at her there was a viscous pop, followed swiftly by another.

*

In Plato's "Allegory of the Cave" he says that the philosopher is like a

prisoner, doomed to look at shadows, thinking he is viewing reality. When he is released, though, he realizes that the shadows are not reality at all, but an abstraction thereof. It's just a matter of having the opportunity to know the difference.

In 2016, artist Andrea Fraser took over the entire 18,200 square feet of the fifth floor of the new Whitney Museum of American Art. Her exhibit, *Down the River*, part of the museum's rotating *Open Plan* show, was only auditory. She had recorded ambient sounds at Sing Sing, the maximum-security prison just up the Hudson River north of New York City. Fraser, who is known for her provocative pieces, cites the show as marrying "the bookend institutions of our increasingly polarised society—institutions that celebrate freedom, and institutions that revoke that freedom." Played on loop are the sounds of footsteps, voices whispering, chatting, yelling, echoing over the intercom, birdsong, doors sliding open, doors slamming shut.

*

BREAKOUT has a sign on the wall of the detention room that reads: *Teach me how to obey.* The local newspaper quotes the owner of the business as saying that she knew our town "deserved something like this." She said, "It's just good, clean fun." A story on NPR about the rise of popularity in escape games quotes a university professor saying that they are an "escape, but at the same time allow us to work through emotional issues, cognitive issues, under the larger auspices of simply playing a game."

Robert Morris's 1961 piece "Box with the Sound of Its Own Making" is a simple wooden box that plays from within a recording of the making of the very box in which it's held: three and a half hours of sawing and sanding and pounding, on loop. The general capacity of human beings: we can do anything, within our specific confinements and containers. We still are anything we ever were: a reeling and clinking of remembered sounds, collected textures.

*

Amanda Berry had a child by her captor. When asked if her daughter is imbued with any bad memories or feelings because she was the product of her captor's abuse, she says no. She says once she gave birth everything got better. She and her daughter decided to play a game, and scream and scream and scream as loud as they could, as often as they could. Finally, she found one of the interior doors they were usually trapped behind unlocked. Amanda held her daughter, who was six at the time, up to an exterior window. She saw a neighbor through the screen, and she and her daughter played the loudest game they ever had. The neighbor responded to the sound and came over to unlock the door.

One of the earliest accounts of abortion holds Saint Bridget at its helm: when a young nun broke her vow of chastity, and grew thick with child, she turned to Bridget, seeking counsel. Saint Bridget sought from deep within herself a potent faith, a crucial concession to human fallibility, a sincere desire to restore to this young woman what she had promised

herself. Upon Bridget's blessing, the woman experienced a waning of her womb—no birth, no blood, no pain, no scorn.

Emma Donoghue's characters Ma and Jack escape their room by playing a game. Ma tells Jack that it's a memory game; he has to remember all these steps in a row: he has to play dead, then count the turns, then jump out of the truck and meet a person. There are seven steps. Jack's not sure if he can remember them all, but he remembers enough to get them rescued.

JUST BEFORE THE BLACKOUT

When I am still a child, we spend summers near Lake Michigan. Some summers the smelt die off en masse and tiny fish carcasses wash up on shore. When the lake recedes, hundreds of fish lie exposed in the arid sand, tangled with seaweed and all the refuse of boats and picnics and decade-long drownings: deflated balloons, champagne corks, soda cans, snack packaging, tampon shells, rigid red swilling sticks, plastic rings of six-packs, inundated lighters, faded sour cream containers, pom-poms and doll parts and lingerie, stuffed animals swollen to their gills, dead gulls rife with rot, pieces of wood before plank or shaft or rudder. Days we spend at the beach, dad teaches little brother and me to build trash castles: collect as much as you can and make the most elaborate thing possible. We each get a plastic bag. We love touching the trash. We love to get dirty. We love permission to do so. Now, the beach looms much larger in my memory. The fish don't smell as bad. Lake levels have dropped, the shore receding into beach grass and various bearberry hybrids transition to tamarack at the edge of forest. In other places, the bristly undergrowth gives way to new property developments. The inheritances of another local politician—long yards, yawning stretches of neatly hammered grass, the stones of the gate stepping along in double time. And so we too fail to imagine another life. I might sentimentalize the heat of the day. I might romanticize my own desires. I might psychologize these motivations. I might mythologize my family's history. A deliquesce of our own ineffectual agendas. Fluid the spaces in which we allow ourselves to fit. The pains held loosely in our joint grip.

*

Atelier Bow-Wow, a modern Japanese architecture firm, claims that the typically unused spaces of an urban landscape are perhaps the most relevant. The firm aspires to fill these overlooked areas with functional structures. Despite the seeming ineffectiveness and, quite frankly, brutal ugliness of these spaces, Atelier Bow-Wow notes that we are still drawn to them by some innate desire.

A founding partner of the firm says: "Pets, companion animals of the people, are usually small, humorous and charming. We find what we call 'pet architecture,' architecture having pet-like characteristics, existing in the most unexpected places within the Tokyo city limits." The small rooms and small spaces are like the small animals we choose to raise and feed and cuddle and love.

For example, the Coffee Saloon Kimoto is a tiny triangular building squeezed into a tiny plot at the interstice of an apartment building's exterior fence and a street running perpendicular to it. This space would otherwise be unused, overrun with grass, or a home for a bench, but is instead now a café in which just four people can fit. Or Tower House, which sits on a very crowded residential block, but only measures ten feet by seventeen feet. The exception here is that the Tower House is five floors tall, still accommodating all of the room a family might need, but in such a way that it doesn't take up very much ground space. Tower House contains nine rooms, none of which have interior walls, creating a sense of motion and purpose in the very narrow space. When you can't build out, you build up. Or House & Atelier, a three-story live-in office, which technically has no footprint, and instead

hangs like an epiphyte off an already existing office building in downtown Tokyo, stopping 25 feet above the street so as to not disrupt the flow of traffic.

These spaces take on the qualities of something that we can nurture, protect, feel needed by, something we can fill, something that needs to be occupied. When the Atelier Bow-Wow team maps the city, they see a series of voids. These buildings let not space go to waste.

*

In the center of Judy Chicago's *The Dinner Party* table, there is a triangular hole and in that hole there is a triangular floor and on that floor the names of 999 women are inscribed. This is the *Heritage Floor*, which, together with the *Heritage Panels*, complete the installation. Upon exiting the exhibition, one winds up in a room of the *Heritage Panels*—large-scale timelines listing all 1,038 women, a tribute to their biographies and accomplishments. These timelines are organized chronologically by the 39 women who get a seat at the table, the other 999 women grouped beneath them according to similarities in craft, profession, passion, categorization.

*

In the mid-1970s, sculptural installation artist Gordon Matta-Clark bought up some cheap property in Manhattan, Queens, Staten Island. This property

consisted mostly of alleyways, unused parking lots, and dumpster-strewn back lots. The city periodically auctions off "gutterspace," which has become city property due to a failure of the previous owner to pay taxes on it. Over a period of time, Matta-Clark purchased ten spaces for about $35 each. He called these spaces *Fake Estates*, a performance piece. Each property is a failure of a failure—the owner failed to upkeep them and Matta-Clark failed to do anything with them once he acquired them. Archived photographs of the spaces show little but fences, trees, wildflowers and weeds, other things that crop up in undisturbed locations.

"Making the right: Cut some- / where between the supports / and collapse," Gordon Matta-Clark writes in felt-tip pen on card stock. The definition of failure—anarchitecture the conception of the anti-space: those concave, delirious cavities.

Matta-Clark's original intentions for *Fake Estates* was to "designate spaces that wouldn't be seen and certainly not occupied… Property is so all pervasive. Everyone's notion of ownership is determined by the use factor." In his final project, *Circus or The Caribbean Orange*, made the year he died, he cut holes in the walls and floors of a townhouse adjacent to the Chicago Museum of Contemporary Art. This changed entirely the space and experience of both the house and the museum—seeing inside from the outside and outside from the inside, looking between the private and the public, in ways that are new and wholly unfamiliar. Lucid and lurid windows into a dimension of otherness. Voids we know not what to do with. Matta-Clark said of *Fake Estates*: "that's an interesting quality; something that can be owned but never experienced." These shapes are not predetermined, nor is there a rote equation by which to decipher the exact perimeters. So much of this is left to chance.

In 1971, Matta-Clark co-founded a restaurant for artists. They named it FOOD. FOOD turned dining into a form of performance and helped define the art community in downtown Manhattan. It was staffed and managed by artists. It became a public space where artists could gather in private, outside of their homes. In the first year of FOOD, the restaurant served 41,272 customers. Matta-Clark's partner, Caroline Goodden says: "Though we consumed food, FOOD consumed us." It was a perpetual dinner party—rabbit stew with prunes, bouillabaisse, carrot soup, ceviche, stuffed tongue Creole, whole sea bass in aspic. The *New York Times* describes the cooking as a kind of performance, the space more like a "utopian enterprise" than a business. This is the same year Alice Waters opened Chez Panisse in Berkeley, California. At this time, SoHo was an industrial wasteland.

When I enter *The Dinner Party*, I am struck by something sacred, aroused by something sudden—like falling asleep mid-Mass only to shock up at the diffuser of frankincense holy smoke wafting among the pews. Judy Chicago's project is swept with silhouetted attempts to fill voids. She sets a place for a single woman and asks that she represent dozens of other women, each void she attempts to fill a synecdoche that creates more voids to surround it—the anarchitecture of history. In early Hindu cultures yonic structures represented the counterpart to the phallus; as the symbol of the goddess the Yoni represented the divine mother, the processes of creation and regeneration. These processes come from a void, a voicelessness, a hole, a lack, an emptiness, a nothingness, a vacuum, an abyss. Judy Chicago gives the vagina a face, literally bringing light to the void, or void to the light. The layering of memories becomes illuminated in that same light. I go with

my mother for her first time, and after we eat goat in the upper rims of a Caribbean restaurant shaped like a boat, tucked down a side street adjacent to the park, in a plot that used to be an alleyway.

*

I've begun using the collective third person in that way that I hate. Walking my puppy under the old railroad tresses that cross the Black Warrior River, the sun knifing its way through wooden beams, he sniffs an old weave buried in the red dirt and tries his teeth on the gravel. We sleep knees together, touching, foreheads closed in upon us and butts jutted out to our respective sides of the bed so in between us lives a diamond of blanket—a soft nipple ripped open by a torn fingernail.

It's hard when you love, but it's even harder to lose love. But this is how we get stronger: we shrink the space. We learn to live in reality rather than in imagination. We learn to let some things go. We learn to accept that there will always be unknowables. To surrender to love is to be vulnerable to appetite.

*

In Gustave Courbet's 1866 painting *L'Origine du monde*, a woman lies on her back, the dimensions of the painting cropping her at the nape of the neck and

mid-thigh. One breast exposed, the other covered by a white sheet. Her legs are slightly akimbo, her pubic hair creeping down around her labia to where the slit becomes her bum, cheeks gathered together at the foot of the bed. This painting suggests that the world comes from a woman's torso. Musée d'Orsay, where it hangs, deems it a "dazzling celebration of the female body."

In 2014, a performance artist named Deborah de Robertis sits in front of *L'Origine du monde*, spread-eagle, in a gold sequin top and no pants. She wears a GoPro on her head. This performance is titled "Mirror of Origin." She's enacting the origin of the world. Life staring back from whence it came. The subject subjected. But the museum is not okay with this. The security guards ask her to get dressed. She refuses. It's pornography, they say, not art. The representation, made by a man, is art, but de Robertis sitting naked in front of it is not. She's arrested and spends two days in police custody for indecent exposure.

Two years later, de Robertis will be arrested again for reenacting Édouard Manet's *Olympia*. In an interview after the performance she says, "If you ignore the context, you could construe this performance as an act of exhibitionism, but what I did was not an impulsive act." She continues: "I've always asked myself: how can you cry out as loud as possible in order to make your point of view exist?"

*

On another visit to the Brooklyn Museum, the *HerStory* gallery, where the

Heritage Panels are typically housed, is under construction. On the next trip, the gallery is open again, but the *Heritage Panels* are gone. Instead, the *HerStory* gallery hosts not the work of Judy Chicago, but an exhibition celebrating agitation and propaganda. According to the Brooklyn Museum, the *Heritage Floor* "provides both a structural and metaphorical foundation for *The Dinner Party*." The women represented on the floor are now corralled by time and subject into groups of which a single woman at the table is the head. This leader is "structurally and metaphorically" held up by the other women. For example, under Judith's place setting are inscribed the names of Naomi, Rachel, Ruth, Eve, and Jezebel—other biblical women. Judith the strong Jewess to represent them all. Or under Sojourner Truth, whose criterion qualify her as personifying both the "oppression and heroism of black women": Ida B. Wells, Josephine Baker, Zora Neale Hurston, Harriet Tubman, and Harriet Beecher Stowe. Or supporting Virginia Woolf: Simone de Beauvoir, Edna St. Vincent Millay, Anaïs Nin, Collette, and Isak Dinesen. The problem is the table is now configured in such a way that, depending on where you stand, these names are obscured, whether by gold table leg or plate runner or tablecloth. Without the *Heritage Panels* to reference, the history is just a hole.

*

I've spent an inordinate amount of time over the last few years in doctors' offices and hospitals and gas stations and prisons and airports. These sad, temporal spaces. The spaces are transient but the sadness is not; it's embedded in

the walls and floors and furniture and plants and art. I've developed strategies for these kinds of places. I keep a book open on my lap. I regard the faces of others. I nod; I say hello. I shrug off my paper shift when the doctor steps into the room. I find some light, through whatever window there may be, whatever shard of glass I can find to blind me through the procedural beats, aching for the shape of the future. We must go in search of a new pattern. Love will fit wherever we let it. These buildings are small and irregularly shaped.

*

The landscape of our interiors, especially when flooding with old pains and the tissue of reopened wounds, leaves little space to cram in something as large as love. But we find ways to make it happen. Because we need to—that emptiness can be unbearable. If there is a void in the layout, we will learn how to fill it, by whatever means necessary. We don't like the barrenness, the confrontation of devastation. We are inventive creatures with the ability to resuscitate our internal habitats. We concern ourselves with spaces that are uninviting, that seem irrelevant, the ugliest pieces of ourselves that we cast off and disregard. We have made habit of shirking from desolation. A revisionist history, an impossible equation. We are supposed to forget everything. That is what makes us human.

Atelier Bow-Wow says that with the Nora House, a project stuck way out in the country, "we developed the ideas horizontally." Here they had room to stretch.

*

Occasionally we hit the great taproot of another person's pain. We can poke around it a little bit with a drill, a shovel, our gloveless fingers. We can probe it, attempt to bring it to the surface. Through the refraction it may even resemble our own pain. But this cannot be replicated. Even when we delude ourselves into believing there is some sort of truth winnowing backward from our advances. Like a dispersing school of sunfish, the smallest, and most vibrantly colored. Pumpkinseed and bluegill rainbowing away from each other. How one falls off, and the formation loses its structure of order. We try, and we fail, we try and we fail. Perhaps we try because we are aware of the impending failure, no matter how much effort we offer forth. We are creatures attracted to such doom. It challenges us. These buildings are squeezed in between more productive structures. These buildings fill a void otherwise left abandoned.

*

The sand feels hottest where the wet meets dry. Our small fingers form small rooms. Our hands turn trash into temporary treasure. Prints dissolve as fast as they form. The smelt rotting down into their feathery spines—a sunbaked smell increasingly unbearable, black flies gathering in bouquets around our hairy ankles. One summer we discovered the carcass-like hull of a sailboat, a small one, the wood weathered and worn pink. This became the table from which we would eat—late, hot breakfasts of cherries and

baguettes shaped like ears of wheat and boiled eggs and whitefish sausage. We are here now. The satisfaction that arrives from making do with what we have access to, what holds momentarily a performative importance. Knowing that this could be enough. To take momentary refuge. We have the land, and the tools.

When I first visited New York City, I was walking to MoMA with a friend and asked him where Rachel Whiteread's *Water Tower* (1998), a sculpture cast in clear resin, was located, thinking that it was probably down somewhere in the East Village. As we entered the museum, he pointed: "there." And it was—right there in the courtyard. On my own, I would have missed it. I would have continued to search as I mapped out my own city, village to village, museum to museum, restaurant to restaurant, apartment to apartment, subway stop to subway stop, eyes to the sky.

<div align="center">*</div>

And She Gathered All before Her

My primary sources for the writing of this book included *The Dinner Party* installation and information available from the Brooklyn Museum and its website, as well as Judy Chicago's book *The Dinner Party: From Creation to Preservation* (Merrell, 2007); her memoirs *Through the Flower* (Anchor Press, 1975) and *Beyond the Flower* (Viking, 1996); the Through the Flower Foundation's website (throughtheflower.org); Gail Levin's *Becoming Judy Chicago* (Harmony Books, 2007); and *The Sexual Politics of the Dinner Party*, edited by Amelia Jones (University of California Press, 1996).

Table of Grief

Shared Dining was on exhibition at the Brooklyn Museum from 7 Aug. to 13 Sept. 2015.

The production exhibition of *Shared Dining* was made possible by the private 501(c)(3) Three Guineas Fund, named after Virginia Woolf, which runs on the platform of "women's education and economic independence as the foundation of social equity and justice." Full images of all the place settings are available at www.3gf.org/shared-dining-1.

On the closing day of the exhibition, there was an afternoon discussion in the theater adjacent to the Sackler Center titled "Touching Humanity: Creativity and Transformation" with Lisette Oblitas-Cruz, Kelly Donnelly, and Wally Lamb, as part of an ongoing series at the Sackler Center, "States of Denial: The Illegal Incarceration of Women, Children, and People of Color." The full talk is available in the Sackler Center's Video Library Collection, accessible through the Brooklyn Museum's website.

Judy Chicago's *The Dinner Party Curriculum* is available at throughthe flower.org.

An Empty Place at the Table. Taber Museum. 7 Oct.–19 Nov. 2005. More information is available at http://lycofs01.lycoming.edu/~estomin/violence/about.htm.

Dunne, Carey. "Inspired by Judy Chicago, Female Inmates Turn Trauma into Art." *Brooklyn Magazine.* 18 Aug. 2015.

Eckardt, Stephanie. "Interview with Carrie Mae Weems Reflects on Her Seminal, Enduring Kitchen Table Series." *W Magazine*. 7 Apr. 2016.

Florin, Karen. "Victim's Family Forgives Driver at DUI Crash Sentencing." *The Day* [New London, CT]. 3 Jan. 2013.

Kennedy, Randy. "In 'Shared Dining,' a Table of Heroines at the Brooklyn Museum." *New York Times*. 7 Aug. 2015.

Mendieta, Ana. *Untitled (Rape Scene)*. 1973. Tate Museum. www.tate.org.uk.

Miller, Nicole. "The Brooklyn Museum's Elizabeth Sackler on Mass Incarceration and the Role of Activist Art." *Hyperallergic*. 29 Jul. 2016.

Moss, Hilary. "Revisiting Carrie Mae Weems's Indelible Series—Almost Three Decades Later." *New York Times Style Magazine*. 5 Apr. 2016.

Richter, Gerhard. *Zwei Frauen am Tisch*. Oil on canvas. 1968. gerhard-richter.com.

Walker, Joanna S. "The Body Is Present Even if in Disguise: Tracing the Trace in the Artwork of Nancy Spero and Ana Mendieta." *Tate Papers*, no. 11, Spring 2009.

Weems, Carrie Mae. *Kitchen Table Series*. Photographs. 1990. carriemae weems.net.

Economy of the Hopeless

Much of the information in this story comes from *Darker than Night: The True Story of a Brutal Double Homicide and an 18-Year-Long Quest for Justice*, a true crime account of the case written by Tom Henderson (St. Martin's, 2006), and newspaper articles from the *Ogemaw County Herald* and the *Oscoda County Herald*. The rest comes from late nights drinking beer around a campfire with my father. Much of this is an elaboration of those stories, and my own memories. My dad told me it'd make a good screenplay. I consider this essay notes toward that screenplay.

I See Myself in You

While conceiving of and writing this book (2010–2016), I probably made two dozen trips to the Brooklyn Museum to see *The Dinner Party*.

Some of the other pieces described in this essay were part of the show *Diverse Works: Director's Choice, 1997–2015*. 15 Apr.–2 Aug. 2015. Others, like Sanford Biggers's piece *Blossom*, were part of *I See Myself in You: Selections from the Collection*. Brooklyn Museum. 26 Aug.–26 Feb. 2017.

Crenshaw, Kimberlé. "Demarginalizing the Intersection of Race and Sex: A Black Feminist Critique of Antidiscrimination Doctrine, Feminist Theory and Antiracist Politics." *University of Chicago Legal Forum*, issue 1, article 8, 1989.

hooks, bell. *Feminist Theory: From Margin to Center*. 2nd ed. South End Press, 2000.

Jones, Richard G. "In Louisiana, a Tree, a Fight and a Question of Justice." *New York Times*. 19 Sept. 2007.

Morgan, Robert C. "Kiki Smith: Allegories on Living and the Mystery of Existence." *Brooklyn Rail*. 8 Jul. 2010.

Parks, Suzan-Lori. "The America Play." *The America Play and Other Works*. Theatre Communications Group, 1995.

Phelan, Peggy. "Broken Symmetries: Sight, Memory, Love." *Unmarked: The Politics of Performance*. Routledge, 1993.

Rosenberg, Karen. "On Being a Woman, From Cradle to Grave." *New York Times*. 12 Feb. 2010.

Rosenbloom, Stephanie. "What Did You Call It?" *New York Times*. 28 Oct. 2007.

Smith, Kiki. *Sojourn*. Brooklyn Museum. 12 Feb.–12 Sept. 2010.

Smith, Sharon. "Black Feminism and Intersectionality." *International Socialist Review*, issue 91, Winter 2013-14.

Tramontana, Mary Katharine. "Stop Calling It a 'Vagina.'" *Vice*. 9 Mar. 2015.

Walker, Alice. *In Search of Our Mothers' Gardens: Womanist Prose*. Harcourt, 1983.

Walsh, Brienne. "Kiki Smith in Her Natural Habitat." *Art in America*. 16 Feb. 2010.

West, Lindy. "I Don't Care About your Stupid Vulva, It's All Vagina to Me." *Jezebel*. Gizmodo Media Group. 26 Jun. 2012.

Origins

Most of these "case studies" came from database searches of local newspapers and obituaries, extending into comments sections, social media sites, and chatrooms.

"2008 Houston Transgender Day of Remembrance: 10 Years 1998–2008." Houston Holocaust Museum and the Transgender Foundation of America. 2008. tgdor.org.

The AMBER™ Alert Program. Alert GPS Holdings, Corp. U.S. Department of Justice. 2015. www.amberalert.gov.

Apuzzo, Matt. "Aiding Transgender Case, Sessions Defies His Image on Civil Rights." *New York Times*. 15 Oct. 2017.

Bui, Lynh. "Where is Relisha? A Year Later, Many Still Long to Find 'Everybody's Child.'" *Washington Post*. 28 Feb. 2015.

Cross, Katherine. "They Were Our Sisters: Feminists Should Not Abandon Mya Hall or Miriam Carey." *Feminsiting*. 2015.

Davey, Monica. "An Iowa Teenager Was Killed in an Alley, But Was It a Hate Crime?" *New York Times*. 26 Oct. 2017.

Felton, Ryan. "Detroit's Transgender Community: 'Police Have No Sympathy for Us.'" *Guardian*. 13 Aug. 2015.

Felton, Ryan. "'They Target Us': Latest US Transgender Murder Reveals Detroit's Intolerance." *Guardian*. 10 Aug. 2015.

Hesse, Monica. "A Young Mother, Gone without a Trace." *Washington Post*. 9 Oct. 2011.

Hogan, Shanna. "Murdered Transgender Phoenix Woman May Have Been Victim of Hate Crime." *Phoenix New Times*. 14 Sept. 2015.

Lewis, Jamal. "The Thrill and Fear of 'Hey, Beautiful.'" *New York Times*. 30 Jun. 2017.

NamUs Missing and Unidentified Persons Database. findthemissing.org. 2008.

Michelson, Noah. "TeeTee Dangerfield Is the 16th Known Woman Killed In U.S. This Year." *Huffington Post*. 2 Aug. 2017.

"Missing White Girl Syndrome." *Journalism Center on Children & Families*. Philip Merrill College of Journalism, University of Maryland. 2012.

Mitchell, Sarah. "Transgender Week of Remembrance: Reflecting Upon Those Lost." *GLAAD Media Institute*. 18 Nov. 2008.

Mitchum, Preston. "Deeniquia Dodds: Another Black Trans Woman Was Killed. Do #BlackLivesMatter Still?" *The Root*. 15 Jul. 2016.

Mock, Janet. *Redefining Realness: My Path to Womanhood, Identity, Love, and So Much More*. Simon and Schuster, 2014.

Muholi, Zanele. *Isibonelo/Evidence*. Brooklyn Museum. 1 May–8 Nov. 2015.

"Rilya Alert History." *Peas In Their Pods, Inc.* 2007.

Romano, Aja. "A Transgender Woman Was Shot in Baltimore and No One Is Talking about It." *Daily Dot*. 30 Apr. 2015.

Schmider, Alex. "Groundbreaking Mic Story 'Unerased' Investigates Transgender Murder Cases." *GLAAD Media Institute*. 8 Dec. 2016.

Schwendener, Martha. "Review: Zanele Muholi, a Visual Activist, Presents 'Isibonelo/Evidence.'" *New York Times*. 14 May 2015.

Scott, Sydney. "Charlamagne Tha God Condemns Violence Against Trans Women After Lil Duval Interview." *Essence*. 4 Aug. 2017.

Stuart, Courteney. "Two Years After Sage Smith's Disappearance, Family Wants Answers Over Discrepancies in Missing Person Cases." *C-Ville*. 19 Nov. 2014.

Talusan, Meredith. "Unerased: Counting Transgender Lives." Ed. Gabriel Arana. *Mic*. 2010–2017.

Teeman, Tim. "Trangender, Murdered, and Missing: Remembering Tee-Tee Dangerfield." *Daily Beast.* 11 Aug. 2017.

Truth, Sojourner. "Ain't I a Woman?" Speech delivered in 1851 at the Women's Rights Convention (Akron, Ohio).

Walker, Alice. "*One* Child of One's Own: A Meaningful Digression within the Work(s)." *Ms.*, Aug. 1979. Collected in *In Search of Our Mothers' Gardens: Womanist Prose.* Harcourt, 1983.

Wang, Yanan. "The Islan Nettles Killing: What the Trial Means to a Transgender Community Anxious for a Reckoning." *Washington Post.* 4 Apr. 2016.

"What Is a Rilya Alert?" *ImaginePublicity.* 13 Jun. 2010.

None of This Makes It into the Still Life

I first saw Artemisia Gentileschi paintings in person at the National Museum of Women in the Arts in Washington, DC, during the exhibition *Italian Women Artists from Renaissance to Baroque*, on display from 16 March–15 July 2007.

Bissell, R. Ward. *Artemisia Gentileschi and the Authority of Art: Critical Reading and Catalogue Raisonné.* Penn State U Press, 1999.

Bohlen, Celestine. "Elusive Heroine of the Baroque; Artist Colored by Distortion, Legend and a Notorious Trial." *New York Times.* 18 Feb. 2002.

Camhi, Leslie. "Drawn to a Story of Art and Rape." *New York Times*. 3 May 1998.

Chicago, Judy and Miriam Shapiro. "Female Imagery." *The Feminism and Visual Culture Reader*. Ed. Amelia Jones. Routledge, 2010.

Garrard, Mary D. *Artemisia Gentileschi: The Image of the Female Hero in Italian Baroque Art*. Princeton U Press, 1989.

Hirsh, Edward. "Sontag, Susan: The Art of Fiction No. 143." *Paris Review*, issue 137, Winter 1995.

Klimt, Gustav. *Judith and the Head of Holofernes*. Oil on canvas. 1901.

Morris, Roderick Conway. "Artemisia: Her Passion Was Painting Above All Else." *New York Times*. 18 Nov. 2011.

Orazio and Artemisia Gentileschi: Father and Daughter Painters in Baroque Italy. Metropolitan Museum of Art. 14 Feb.–12 May 2002.

Smollar, David, Patrick McDonnell, and Nora Zamichow. "Vision of Chaos Around Chula Vista Billboard: Phenomenon: Authorities Voice Public Safety Concerns as Thousands More Flock to See Purported Image of Slain Child." *Los Angeles Times*. 20 Jul. 1991.

Sontag, Susan. *Regarding the Pain of Others*. Farrar, Straus, and Giroux, 2003.

Vreeland, Susan. *The Passion of Artemisia*. Viking, 2001.

Arch of Nemeses

I'm fascinated by relationships in the natural world mapped onto a human landscape. Most of the information in this essay is gleaned from various classes I've taken, books I've read, people I've met, things I've picked up along the way, mistakes I've made.

Allen, Polly. "In the Frame: Nan Goldin, 'One Month After Being Battered.'" *Bitch Media.* 30 Nov. 2011.

Als, Hilton. "Nan Goldin's Life in Progress." *New Yorker.* 4 Jul. 2016.

Frank, Priscilla. "The Life of Forgotten Feminist Ana Mendieta, as Told by Her Sister." *Huffington Post.* 7 Mar. 2016.

Goldin, Nan. *The Ballad of Sexual Dependency.* Aperture Foundation, 1986.

Goldin, Nan. *The Devil's Playground.* Phaidon, 2003.

Harris, Trudier. "Celebrating Bigamy and Other Outlaw Behaviors: Hurston, Reputation, and the Problems Inherent in Labeling Janie a Feminist." *Approaches to Teaching Hurston's* Their Eyes Were Watching God *and Other Works.* Ed. John W. Lowe. MLA Publications, 2009.

Heuer, Megan. "Ana Mendieta: Earth Body, Sculpture and Performance." *Brooklyn Rail.* 19 Sept. 2004.

Hurston, Zora Neale. *Their Eyes Were Watching God.* Illini Books, 1937.

Katz, Robert. *Naked by the Window: The Fatal Marriage of Carl Andre and Ana Mendieta*. Atlantic Monthly Press, 1990.

Johnson, Ken. "Bleak Reality in Nan Goldin's 'The Ballad of Sexual Dependency.'" *New York Times*. 14 Jul. 2016.

Marcus, Greil. "Songs Left Out of Nan Goldin's *Ballad of Sexual* Dependency." *Aperture*, issue 197. 2009.

The Marina Abramović Institute. https://mai.art/

Marina Abramović: The Artist is Present. Dir. Matthew Akers and Jeffrey Dupre. Film. 2012.

McDermon, Daniel. "Nan Goldin Wants You to Know She Didn't Invent Instagram." *New York Times*. 15 Aug. 2016.

Mendieta, Ana. "Untitled (Death of a Chicken)." Film. 1974. *My Body Is the Event*. Mumok Gallery, Vienna. Uploaded by Iman West. Vimeo. 2015.

Mendieta, Ana. "Blood Sign." Film. 1972. Uploaded by juanaguilarjimenez. YouTube. 2 Feb. 2011.

Pearson, Jesse and Richard Kern. "An Interview with Marina Abramović." *Vice*. 31 Oct. 2010.

Popkey, Miranda. "Nan Goldin." *Paris Review*. 21 Apr. 2011.

Stamberg, Susan. "Stieglitz and O'Keeffe: Their Love and Life in Letters." *NPR's Morning Edition*. 21 Jul. 2011.

Viso, Olga M. et al. *Ana Mendieta: Earth Body: Sculpture and Performance, 1972–1985*. Hirshhorn Museum and Sculpture Garden, Smithsonian Institute. 2004.

Walker, Alice. "Looking for Zora" and "Zora Neale Hurston: A Cautionary Tale and a Partisan View." *In Search of Our Mothers' Gardens: Womanist Prose*. Harcourt, 1983.

The Last Supper

Calle, Sophie. *Double Game*. Violette Editions, 1999.

Castro, Fernando. "Judy Chicago, Linda Nochlin and the Birth of Feminist Art." *Literal Magazine*, issue 31. 11 Jan. 2013.

Collins, Lauren. "Burger Queen." *New Yorker*. 22 Nov. 2010.

Crenn, Dominique. "We're Not 'Female Chefs,' Just Chefs." *Munchies*. Vice. com. Reprinted 8 Mar. 2017.

Cunningham, Brent. "Last Meals." *Lapham's Quarterly*, vol. 4, no. 4. 2013.

Dark Rye. "Julie Green: The Last Supper." *Huffington Post*. 19 May 2013.

Dead Man Eating Weblog. deadmaneating.blogspot.com.

Death Penalty Information Center. deathpenaltyinfo.org. 2017.

Dickinson, Emily. "1702" in *The Collected Poems of Emily Dickinson*. Ed. R.W. Franklin. Belknap Press, 1999. Page 612.

Dunea, Melanie. *My Last Supper: 50 Great Chefs and Their Final Meals*. Bloomsbury, 2007.

Dunea, Melaine. *My Last Supper: The Next Course: 50 More Great Chefs and Their Final Meals*. Rodale, 2011.

Duras, Marguerite. *Outside: Selected Writings*. Beacon Press, 1986.

Eckhardt, Stephanie. "Why Judy Chicago, 78-Year-Old Feminist Godmother of Vagina Art, Is Having a Revival." *W*. 23 Oct. 2017.

Fineman, Mia. "Table for 39." *Slate*. 25 Apr. 2007.

Fisher, M.F.K. "Consider the Oyster" and "An Alphabet for Gourmets." *The Art of Eating*. Collier Books, 1990.

Gill, James. "Tom Kerridge: Some Female Chefs Don't Have the 'Fire in the Belly' to Make It at the Top Level." *RadioTimes*. Immediate Media Co. 7 Oct. 2014.

Goldfield, Hannah. "Death-Row Dining." *New Yorker*. 26 Sept. 2014.

Golgowski, Nina. "Death Row-Themed Restaurant Rethinks Serving Famous Last Meals after Backlash." *New York Daily News*. 17 Sept. 2014.

Harris, Jessica B. "A Way With Words and a Spice Rack: Recalling Maya Angelou's Love of Cooking." *New York Times*. 2 Jun. 2014.

Henderson, Fergus. *Nose to Tail Eating: A Kind of British Cooking*. Bloomsbury, 2004.

Hoby, Hermione. "Michael Landy: Modern Art Is Rubbish." *Guardian*. 16 Jan. 2010.

Johnson, Kirk. "Dish by Dish, Art of Last Meals." *New York Times*. 25 Jan. 2013.

Kristeva, Julia. *Powers of Horror: An Essay on Abjection*. Trans. Leon Roudiez. Columbia University Press, 1982.

Lorde, Audre. "The Master's Tools Will Never Dismantle the Master's House." *Sister Outsider: Essays and Speeches*. Crossing Press, 1984.

Matthew 5:13. The Bible, King James Version.

Moran, Caitlin. *How to Be a Woman*. Ebury Press, 2011.

Neilson, Laura. "Grant Achatz, April Bloomfield, Anthony Bourdain and Others Dish on the Plates They Made for Daniel Boulud." *New York Times Style Magazine*. 26 Sept. 2014.

NPR Staff. "Food for Thought: Chefs Pick Their Last Meal On Earth." *Weekend Edition Sunday*. NPR. 30 Oct. 2011.

Puchko, Kristy. "15 Facts About *The Last Supper*." *Mental Floss*. 2 Apr. 2017.

Selby, Jenn. "Tom Kerridge: Female Chefs Don't Have 'Fire' to Make It to Top Level - but 'Girls in the Kitchen I Like - It Makes It not so Aggressive.'" *Independent UK*. 7 Oct. 2014.

Shapiro, Celia A. *Last Supper*. 2001. Photographs at celiaashapiro.com.

Sooke, Alistair. "Hay 2013: Artist Cornelia Parker on Five Works and the Pieces that Inspired Them." *Telegraph*. 24 May 2013.

Varrino, John. "At Supper with Leonardo." *Gastronomica*, vol. 8, no. 1. 10 Feb. 2008.

Wohlfert, Lee. "Sassy Judy Chicago Throws a Dinner Party, but the Art World Mostly Sends Regrets." *People Magazine*. 8 Dec. 1980.

Salt of the Earth

Anderson, Deonna. "Turning Prisons into Haunted Houses." *The Marshall Project*. 4 Jul. 2016.

Begley, Josh. "What It's Like to Play a Round of Golf at a Maximum Security Prison." *Deadspin*. 7 Nov. 2012.

Bentley, Jules. "Golfing with the Guards at Angola Penitentiary." *Vice Sports*. 24 Sept. 2015.

Breakout Escape Game. breakouttuscaloosa.com. 2016.

Brininstool, Andrew. "How New Mexico Transformed the Site of a Deadly Prison Uprising into a Tourist Destination." *Vice*. 30 Sept. 2015.

"Cleveland Kidnapping Fast Facts." *CNN*. 5 May 2017.

Donaghue, Erin. "The Cleveland Kidnapping Case: A Timeline of Events." *CBS News*. 6 May 2014.

Donoghue, Emma. *Room*. Little, Brown and Company, 2010.

"'Escape Rooms' Challenge Players to Solve Puzzles to Get Out." *All Things Considered*. NPR. 20 Oct. 2015.

Gilbert, Samuel. "Old Main Prison: A Tour Through American Prison History." *Al Jazeera*. 26. Mar. 2016.

Gould, Mary Rachel. "Discipline and the Performance of Punishment: Welcome to The Wildest Show in the South." *Liminalities: A Journal of Performance Studies*, vol. 7, no. 4. 2011.

Halford, Macy. "Emma Donoghue Chats About 'Room.'" *New Yorker*. 21 Jan. 2011.

Johnson, Ellen. "Tuscaloosa Escape Room Offers Thrills and Chills." *The Crimson White*. 17 Sept. 2017.

Knight, Michelle and Michelle Burford. *Finding Me: A Decade of Darkness, a Life Reclaimed*. Hachette Books, 2014.

Lau, Maya. "Louisiana 'Escape From Angola' Triathlon Canceled after Criticism, Featured Accommodations in Old Death Row, 'Keys to Prison' Prize." *Advocate*. 6 Mar. 2016.

McQueen, Alexander. *Savage Beauty*. Metropolitan Museum of Art. 4 May–7 Aug. 2011.

Milligan, Lauren. "Fashion Flashback: McQueen's Asylum Show." *Vogue*. 7 Aug. 2014.

Moss, Thylias. "Salt of the Earth" in *Hosiery Seams on a Bowlegged Woman*. Cleveland State U Poetry Center, 1983.

Olley, Michelle. "Diary Entries by Michelle Olley on Appearing in *VOSS*, spring/summer 2001. Recorded over 18 Sept.–27 Sept. 2000. Available at blog.metmuseum.org/alexandermcqueen/michelle-olley-voss-diary/.

Read, Max. "The Hero Who Rescued Three Kidnapped Women in Cleveland Is Hilarious." *Gawker*. 7 May 2013.

Witkin, Joel-Peter. *Gods of Earth and Heaven*. Twin Palms Publisher, 1989.

Woodley, Karin. "Inner Sanctum: The Dinner Party." *Artrage.* 1985. Collected in *Visibly Female: Feminism and Art Today.* Ed. Hilary Robinson. St. Martin's Press, 1988.

Yardley, Jim. "Italian Cuisine Worth Going to Prison For." *New York Times.* 5 Mar. 2016.

Just Before the Blackout

Abrams, Amah-Rose. "Nude Performance Artist Speaks Out after Musée d'Orsay Arrest: Deborah de Robertis is Accusing the Paris Museum of Being Hypocritical." *Art World.* 19 Jan. 2016.

"Artist Deborah de Robertis Flashes Paris Museum Goers on May 2014." User: Александр Захаров. YouTube. 14 Sept. 2017.

Attlee, James. "Towards Anarchitecture: Gordon Matta-Clark and Le Corbusier." *Tate Papers*, no. 7, Spring 2007.

Cottrell, Claire. "10 Smart, Skinny Buildings Squeezed into Teeny Tiny Spaces." *Flavorwire.* 29 Jan. 2013.

Freeman, Anna. "Why This Artist Flashes Her Vagina in Museums and Galleries." *Arts + Culture, Dazed.* 23 Nov. 2016.

Heyman, Stephen. "Deborah de Robertis: Shocking for a Purpose." *New York Times.* 29 Sept. 2016.

Kastner, Jeffrey, Sina Najafi and Francis Richard. *Odd Lots: Revisiting Gordon Matta-Clark's* Fake Estates. Cabinet Books, 2005.

Kennedy, Randy. "When Meals Played the Muse." *New York Times*. 21 Feb. 2007.

Matta-Clark, Gordon. *Circus or The Carribean Orange*. Contemporary Art Museum of Chicago. 1978.

Neuendorf, Henri. "Performance Artist Arrested Again at Musée d'Orsay after Reenacting Manet's 'Olympia.'" *Art World*. 18 Jan. 2016.

Scavone, Enzo. "When Artists Lived in SoHo: A Look Back at the Restaurant FOOD by Gordon Matta-Clark and Carol Goodden." *untapped cities*. 12 Dec. 2013.

White, Mason. "Atlier Bow-Wow: Tokyo Anatomy." *Archinect*. 22 May 2007.

ACKNOWLEDGMENTS

I'd like to thank Renee Gladman for choosing this manuscript, as well as Caryl Pagel, Hilary Plum, and their team at the CSU Poetry Center. I'd also like to thank the journals in which parts of this manuscript first appeared, in different form, for seeing something of worth in the ideas: *DIAGRAM*, *Territory*, *storySouth*, *Sonora Review*, *Masque & Spectacle*.

Thank you to Laura Peterson for creating an amazing collage for the cover of this book, and also for her friendship and endless conversations about art.

These essays wouldn't have happened without the encouragement, elicitation, and energy of Liana Imam, Ashley Chambers, Ryan Bollenbach, Kayleb Rae Candrilli, Kit Emslie, Jenifer Park, Maggie Nye Smith, P.J. Williams, Nabila Lovelace, Christopher O. McCarter, Josh English, Anna Ash, Hannah Ensor, Schlomo Steel, Lauren Keils, Caitlin Shrestha, Claire Sylvester Smith, Keith Taylor, Barbara Hodgdon, Thylias Moss, Joel Brouwer, Sharon O'Dair, Hali Felt, Andy Grace, Anne Carson and Currie.

And to all the women I've been lucky enough to share a kitchen with, for patience, laughter, and nourishment: April Bloomfield, Christina Lecki, Charlene Santiago, Jasmine Shimoda, Joyce Liu, Burcu Aydeniz, Shayna Hamidi, Blair Nosan, and the Medoros: Catia, Manuela, and Francesca. And Bobbi, too.

Thanks to my family—Mom, Dad, Casey, Grace, Connor, Frankie—for their endless love, and for continually challenging me to become a better thinker, writer, and person.

A final thank you to Ms. Sarah Kovner, a poet I met at the end of her life, who, over many ham sandwiches and cups of tea, inspired me to write everything I could before it's all over, and to be grateful for it.

BIOGRAPHY

Shaelyn Smith grew up in northern Michigan and received her MFA in creative nonfiction from the University of Alabama. She lives and works in Auburn, AL.

RECENT CLEVELAND STATE UNIVERSITY
POETRY CENTER PUBLICATIONS

POETRY

The Hartford Book by Samuel Amadon
The Grief Performance by Emily Kendal Frey
My Fault by Leora Fridman
Stop Wanting by Lizzie Harris
Vow by Rebecca Hazelton
The Tulip-Flame by Chloe Honum
Render / An Apocalypse by Rebecca Gayle Howell
A Boot's a Boot by Lesle Lewis
In One Form to Find Another by Jane Lewty
50 Water Dreams by Siwar Masannat
daughterrarium by Shelia McMullin
The Bees Make Money in the Lion by Lo Kwa Mei-en
Residuum by Martin Rock
Festival by Broc Rossell
The Firestorm by Zach Savich
Mother Was a Tragic Girl by Sandra Simonds
I Live in a Hut by S.E. Smith
Bottle the Bottles the Bottles the Bottles by Lee Upton
Adventures in the Lost Interiors of America by William D. Waltz
Uncanny Valley by Jon Woodward
You Are Not Dead by Wendy Xu

ESSAYS

A Bestiary by Lily Hoang
I Liked You Better Before I Knew You So Well by James Allen Hall

TRANSLATION

I Burned at the Feast: Selected Poems of Arseny Tarkovsky translated by Philip Metres and Dimitri Psurtsev

For a complete list of titles visit www.csupoetrycenter.com